BANKSY

# LOCATIONS & TOURS
# VOL 1

## A COLLECTION OF GRAFFITI LOCATIONS
## AND PHOTOGRAPHS IN LONDON, ENGLAND

### MARTIN BULL

#### US EDITION

Totally updated, rewritten, and redesigned just for you...
All photos improved & many new inset photos added    Extra love & peace included

BANKSY LOCATIONS & TOURS VOL 1
A COLLECTION OF GRAFFITI LOCATIONS AND PHOTOGRAPHS IN LONDON, ENGLAND
The author asserts his moral right to be identified as the author of this work. Copyright ©
Martin Bull
This edition copyright © 2011 PM Press

ISBN: 978-1-60486-320-8
Library of Congress Control Number: 2011927942

10 9 8 7 6 5 4 3 2

Based on a design by Courtney Utt

PM Press
PO Box 23912
Oakland, CA 94623
www.pmpress.org

Printed in the USA by the Employee Owners of Thomson-Shore in Dexter, Michigan.
www.thomsonshore.com

# THE BIG ISSUE FOUNDATION

My website is dedicated to Les, a *Big Issue* seller I met in Bristol. Chatting with him reminded me to try not to judge a book by its cover and to take time to listen to people. It's something I have to remind myself of every day, though, and I still often fail!

For copies directly sold via the author, 25% of the gross sale price will be donated to The Big Issue Foundation (registered charity no. 1049077). For copies sold via bookshops, 10% of the author's gross sale price will be donated.

All sales of two limited edition versions of this book and some black-and-white photos have been donated to them.

Over £30,000 has been donated so far from various sales and fundraising activities.

The Big Issue Foundation does amazing work to assist homeless people, enabling them to gain control of their lives and achieve greater self-reliance and independence.

Please visit and support them if you feel the same as me – www.bigissue.co.uk

# CONTENTS

# INTRODUCTION

Before this new second US edition was released, I used to introduce this book by asking if the reader fancied wandering the streets of London, looking for (mainly) Banksy graffiti (and sidetracking to various quirky local attractions in parts of London they may never have visited before), or whether they preferred just sitting at home in a comfy chair (slippers and pipe optional, but highly recommended in these days of weapons of mass destruction...), looking at photos of his street work and reading about them...?

Well, this unique, 100% unofficial book still just about lets you do either, but in reality it is more of a history book now, because not surprisingly lots of the graffiti has gone since the book was first released in 2006. The 'tours' that originally showed you how to link all the Banksy graffiti into three walking tours are now pretty much redundant. I have therefore slightly amended the original title, taken out the directions from one location to the other, and changed the design of the book so that it is very clear which locations are still 'active' (as of May 2011 usually) and which aren't. Readers who are interested can obviously still happily visit the 'active' ones and get free updates from me as to which are still living. But don't expect to be able to make the few remaining ones into an intensive tour anymore. Most people will unashamedly be just reading the book on the sofa or the toilet.

Oh well, it was good whilst the tours side of the book lasted, and I still feel the book has a lot of worth, because the tours and locations of 2006 – 2009 are now the graffiti archaeology of tomorrow. The bottom line is that I supply the information and the history, and you can use it as you wish.

Just don't expect pseudo-intellectual ramblings in this book on what this graffiti all means, how the Banksy phenomenon has taken off, who he is, who he isn't, why my grandmother looks a bit like Arsène Wenger, or what the difference is between graffiti and street art. I'm not that interested in intellectualising all this. A bloke creeping around in the middle of the night, getting sweaty and potentially getting nicked for painting for free on the streets, is just about the most non-intellectual situation I can imagine in life.

I'll let you decide what it means to you.

**Martin Bull**

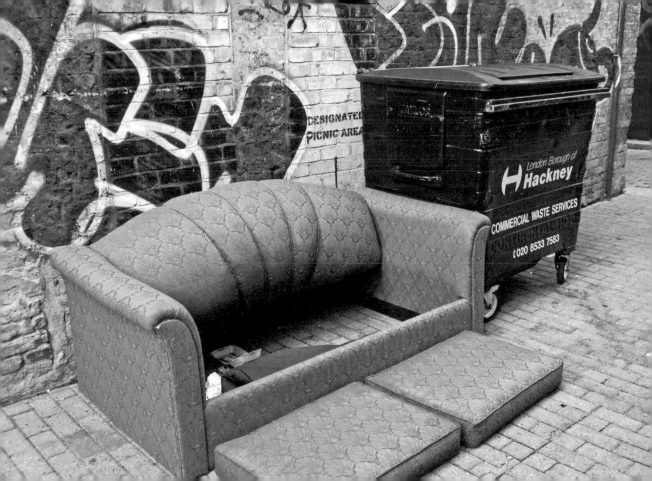

# THE GEEKY BIT...

Throughout 2006 many people responded to my leading questions and downright Miss Marple-esque annoyance about where to find a lot of this graffiti. I also discovered a lot myself whilst wandering the streets like a stray dog, following hunches and leads, and smelling the odd lamp-post to get that authentic feel. Over the last four years I have continued to give and take information from various sources.

In an effort to share this info and to let people take their own photos (if they want to – it's not compulsory) I gave a lot of free location information on internet groups/forums/maps, and in 2006 I ran a series of free guided tours in London. All of this then accidentally formulated this book, especially the first two UK editions when the 'tours' were more do-able.

Although the days of 'tours' are over, some of the locations in the book still exist (as of spring 2011 usually), and I will post free book/status updates on my own website: **www.shellshockpublishing.co.uk**
And I can send these updates to you by email if you want. Just email me at **m@shellshockpublishing.co.uk**
I will try to continue to contribute graffiti/location information on the internet, especially on the following sites:
· The Banksy group on Flickr: **www.flickr.com/groups/banksy/**
· The Banksy Forum: **www.thebanksyforum.com**

# BUY BYE BYE, SALE SELL SELL
## (A.K.A. LEAVE THEM ON THE STREETS PLEASE!)

Without wishing to sound too grave or pompous (this is graffiti after all, where there aren't any rules really), I feel that recent circumstances mean it's an apt time to give a summary of my personal feelings on removing, buying, and selling street pieces by Banksy. You of course have free will to do whatever you want to, hopefully using your conscience and internal moral compass.

First things first. I am just talking about pieces done on the streets, and *not* canvases, screenprints, etc. Without even knowing what others may think, my natural feeling has always clearly been to 'leave them on the street where they are supposed to be'. Simple as that. I don't need to intellectualise it by going on about the utilitarian 'gift' of work to the street, and the 'democracy of street art'. Whilst people have these inane discussions, real writers are taking risks out on train tracks and climbing shonky drainpipes.

This issue has raised its head higher for me because some people have tried to use *BLT* as a type of provenance when they are dealing in street pieces. For example, the door the Refuse Store Rat in Clerkenwell was on (see location F8) was removed, and in Sept 2008 it turned up in a Contemporary Art auction by the Scottish auctioneer Lyon & Turnball. This auction controversially contained five Banksy street pieces, all allegedly 'authenticated' by Vermin, a company that has no connection to Banksy.

I was very unhappy when a friend told me they had referenced this book in their description of the piece. I rattled off a complaint to Lyon & Turnball, but they refused to take out the reference to *BLT*. My follow-up emails went unanswered (not surprisingly I guess, especially as the third one was childishly smug that their auction had been a colossal flop). The estimate price was £20–25,000, but it remained unsold.

My books are a bit of fun really and are not meant to provide some sort of claim of provenance for a street piece. I'm just a big geeky fan of Banksy's work, and these are meant as information books and DIY guides. Believe it or not, these books have actually been quite hard work as well. They are not sales catalogues, nor a map to find what pieces to steal, take to auction or buy from the owner. And anyway, Banksy and Pest Control are the only people that can provide 'provenance' for anything (definitely not me!), and quite correctly none of them will give provenance on street pieces because they don't want to. Is that an accident? No, it's because street pieces are meant for the street.

This particular auction led to a rare statement from Banksy, as reported by the *Evening Standard*. He said: "Graffiti art has a hard enough life as it is — with council workers wanting to remove it and kids wanting to draw moustaches on it, before you add hedgefund managers wanting to chop it out and hang it over the fireplace. For the sake of keeping all street art where it belongs, **I'd encourage people not to buy anything by anybody unless it was created for sale in the first place.**" (my emboldening)

Similarly, Pest Control added a note of warning about street pieces, as it said on its website: "[Banksy] would encourage anyone wanting to purchase one of his images to do so with extreme caution, but does point out that many copies are superior in quality to the originals. Since the creation of Pest Control in January 2008 we have identified 89 street pieces...falsely attributed to the artist."

**BLT TIP:** The most informative internet piece on this thorny subject can be found at http://www.thisislondon.co.uk/standard/article-23560543-banksys-dont-bank-on-it.do

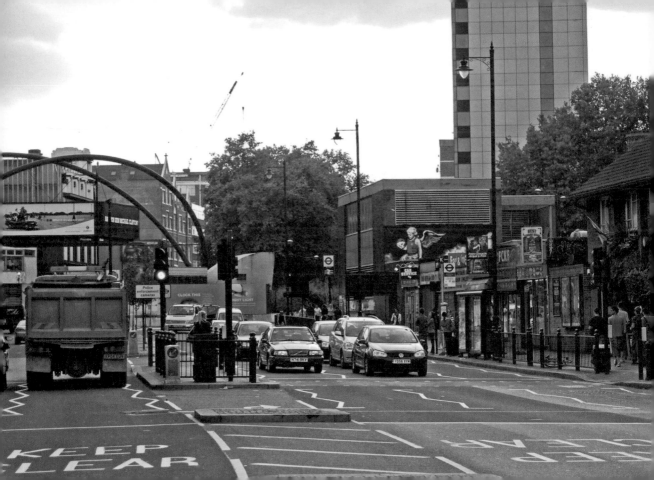

# HOXTON & SHOREDITCH

This was the biggest tour by far, and at a pretty decent pace it took us three hours. It could have been far more if I included all the local streets and all the local graffiti. It is everywhere, although the Council do seem to be less tolerant now. And it's ever-changing, so even though most of the featured graffiti has now gone, you're bound to always find something new in this area, or even something you never noticed before.

Literally stumbling across 'the maid' (see S20) early-ish one Sunday morning in May 2006 (I suspect Banksy did it in the small hours of that morning) is a pleasure you can only really get by wandering around, keeping your eyes open, and following your destiny. So I suggest getting out of the house and taking the dog for a walk if you can (even if you don't have a dog...).

This tour went around the capital of UK street art – Hoxton, Old St, Shoreditch, and Brick Lane – the creative, yet run-down, nuevo-trendy East End. The streets (and railway bridges and skanky alleys) are literally awash with graffiti of different styles, plus paste-ups, stickers, installations, art projects and all sorts of weird and wonderfully creative ramblings (picture frames on the street, nailed up art, tattooists, photographers, fashion victims and maybe even Nathan Barley on his poxy BMX if you are unlucky enough).

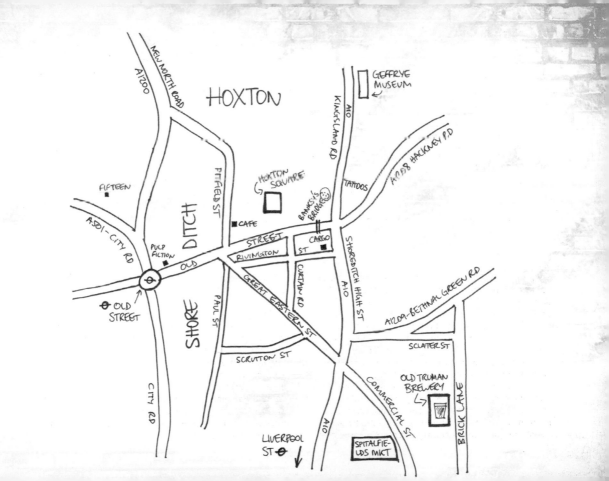

**POISON RAT**
Postcode: EC1Y 1AU
Map/GPS reference: TQ 32796 82288

**Location & Any Other Info I Can Think Of**
Oliver's Yard, just off City Rd (A501). As seen in the Banksy books and on his website. Not surprisingly it's now very faded (it's been there since at least mid-2005) but it's the only Poison Rat left in the area, and is complete with green waste spewing across the pavement.

**Status**
Still just visible (June 2011).

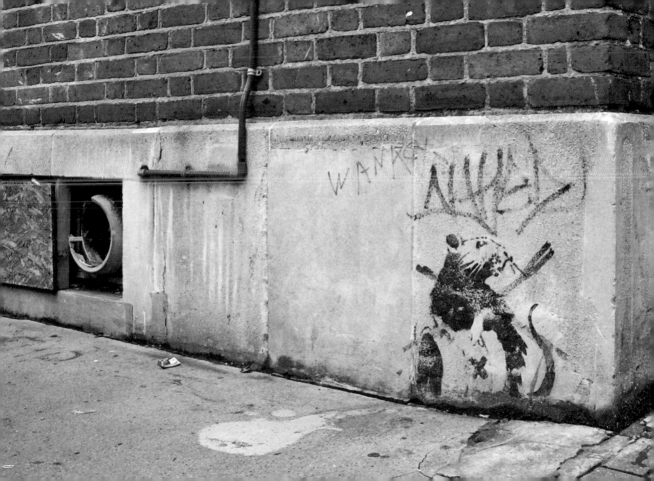

**CHECK OUT THE WALL...**
Postcode: EC1V 2NR
Map/GPS reference: TQ 32706 82522

**Location & Geeky History**
By Exit 8 of Old Street tube station. It may be white, it may be black, it may have art on it, it might not... It used to be an ever-changing, open-air gallery. The 'writer' Arofish was probably the first to paint this wall white and then come back later to add some art to it (he used the old trick of posing as a workman – it's amazing what you can get away with in life when you have a £2.99 hi-viz jacket on!). After that it had a succession of art and paint-overs, including this cheeky reference by El Chivo to the repainting, but since 2007 it's mainly been blank.

Soma by El Chivo, in June 2006, followed by 'paint it black...paint it white...' by El Chivo, Oct 2006 (both soon painted over)

**MICROPHONE RAT**

This used to live on an old disused entrance to Moorfields Eye Hospital on City Rd (by Cayton St – Postcode: EC1V 9EH. Map/GPS reference: TQ 32551 82701)

It was a great example of a large microphone rat, although I like to think of it as a rat belting out 'My Way' on a karaoke machine or maybe toasting at a sweaty sound system clash in Kingston (Jamaica, not Upon-Thames).

It was there since at least mid-2004. For half of 2006 it was covered up during renovations to the building, but it managed to survive. It was released again in October 2006 and endured nicely until late November/early December 2007 when a great big bit of wood was put over it. The wood was weakly screwed over it and the rat could still be seen under the wood for several years until the hospital decided to auction it off on 7th October 2010. It raised £30,000 for research into new treatment for eye disease.

The *Evening Standard* reported that "Banksy and his team were involved throughout the planning and had helped the Moorfield to cut the picture...from the wall" and that it seemed to be the man himself who made last-minute restorations to the work.

There was the obligatory tinge of irony to the auction though. Jeffrey Archer was the 'celebrity' auctioneer and it was held in the Saatchi Gallery. Banksy famously remarked in the ultra-rare face-to-face interview with the *Guardian* in 2003, "I wouldn't sell s**t to Charles Saatchi. If I sell 55,000 books and however many screenprints, I don't need one man to tell me I'm an artist... No, I'd never sell anything to him." And in what seems like another reference to him, Mr. B also told artnet in 2003 that, "I don't like the gallery system. These days, the value of art seems to come down to whether one millionaire likes it or not."

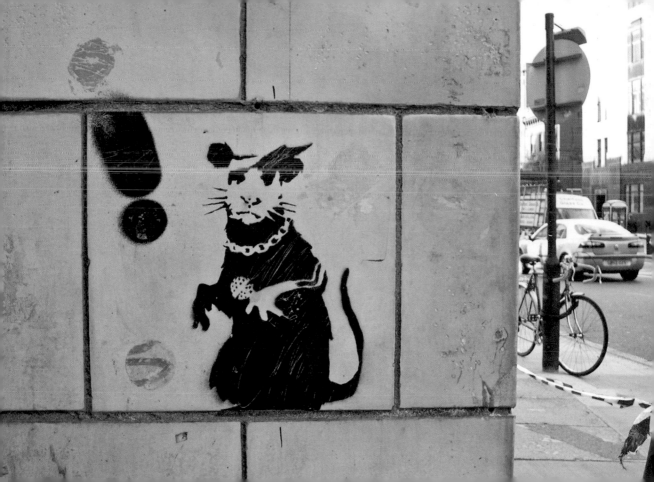

### CUTTING RATS & GANGSTA RAT

These cutting rats used to be outside Fifteen Restaurant, on Westland Place (postcode: N1 7LP. Map/GPS reference: TQ 32551 82807).

Being an advocate for tree-hugging pinko liberals... this stencil was done next to Jamie Oliver's 'social restaurant' Fifteen in oh so trendy Hoxton, as if some rats were breaking into it. He also did the same stencil on the gates to the Greenpeace office in London (see *BLT Vol 2*). Is there no end to this man's humour?

They had been there since at least mid-2004, but they disappeared circa March 2007. The rats were actually on panes of blackened glass, which were removed and replaced, presumably by the owners of the building.

A gangsta rat lived just around the corner from at least 2005 (see inset photo – the best photo I have, I'm afraid. It had gone by the time I went back to get better ones) but that was whitewashed in 2006, well before the cutting rats went.

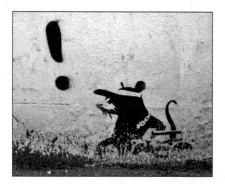

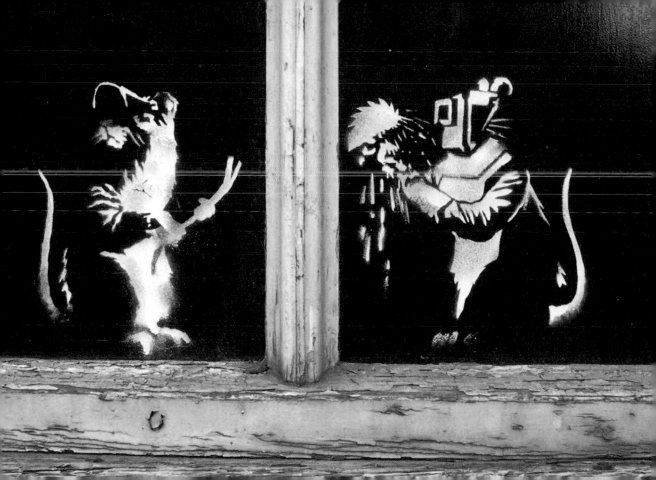

## 'SMILEY' COPPER

This used to be on a slightly tucked away wall, on the corner of Vestry St and East Rd (postcode: N1 7LP. Map/GPS reference: TQ 32551 82807).

The photo shows the 'Smiley' Copper on the badly peeling wall, after having been amended by an artist unknown to make it a rather unique 'blank faced' copper instead. Also rather uniquely, a large Banksy tag covered the stomach area.

This exact graffiti is shown in Banksy's book *Wall and Piece* and has also been on his website, where it introduced the idea of 'Clubism', a tongue-in-cheek new movement in art ("it's dirty and mindless but it's the best way to get over a bad week at work").

It had lived there since at least spring 2004 (and possibly a lot earlier than that) but was badly buffed in February 2007. The wall looked a mess! Shepard Fairey later added a paste-up to the wall during his November 2007 visit to London (see inset photo, right).

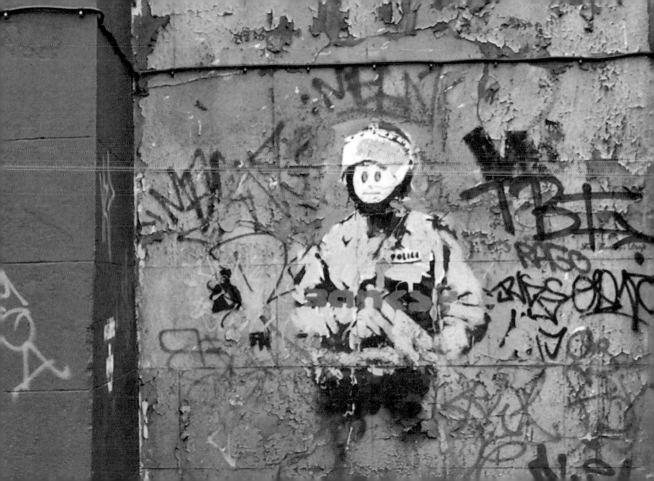

## GIRL WITH BALLOON

This was on the side of some flats on the New North Rd (A1200), close to Wimbourne St (postcode: N1 6TA. Map/GPS reference: TQ 32696 83342) and had been shown on Banksy's website many years ago.

Sometime around spring 2006 the balloon was repainted, by a person unknown. The whole piece was painted over in March 2007 but could still be vaguely seen through the new grey paint. I suspected this might happen as the local housing estate was being renovated and when that happens they generally give everything that doesn't move a coat of paint as well. The wall has since had a massive piece by the Toasters on it for several years now.

Although this was the last Girl with Balloon to survive, there was a point when there were loads of them in London! Versions existed around the South Bank (one was on the east side of Waterloo Bridge and featured in *Wall and Piece*; others existed on Clink St, and on the east side of Blackfriars Bridge — that one featured in Woody Allen's film *Match Point*); Shoreditch (there was one on Paul St, one on the corner of Pitfield St and Bowling Green Walk, and one on Provost St); and, Clerkenwell (St. John St).

This image is consistently chosen by fans (especially females) as their favourite image, and its meaning is endlessly debated on dull forums. Is the girl grabbing for the balloon (lost love?) or is she letting it go? Who cares? I would have thought it was relatively clear, as his books give the following caption "When the time comes to leave, just walk away quietly and don't make any fuss." When Pictures On Walls (POW) used to sell the image as a print, the description read, "Banksy was never his mother's favourite — and he was an only child."

Erika and Nhatt at the Girl with Balloon

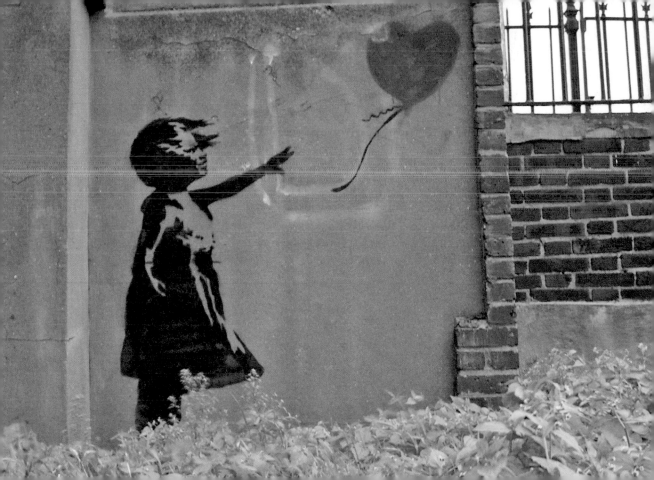

## CANAL HOODIE

This existed from at least early 2005 under the foot bridge that goes over the Regent's Canal. The bridge is the pedestrianised section of road between Shepherdess Walk (B144) and Packington Square (postcode: N1 7JL. Map/GPS reference: TQ 32282 83375).

In late May 2010 it was totally blacked out though, and replaced by the following comment – 'I see a Banksy and have got to paint it black – Team Robbo rollin with the Stones' – alongside a pastiche of John Pasche's famous Rolling Stones mouth logo. This was presumably part of the longer-term fallout from the now infamous 'Robbo' incident (in December 2009 Banksy amended/went over a very old piece by veteran writer Robbo further along the Regent's Canal in Camden, and all hell broke loose afterwards).

It was a good example of how (I assume) Banksy reuses stencils, as it seems the same as the one used for the 'Tourist Information' guy, just off the Hackney Rd (Ion Square – see inset photo – it had almost gone by the time I found it in 2006 and has now faded even more into obscurity), and another version that popped up in Hoxton Square in 2004.

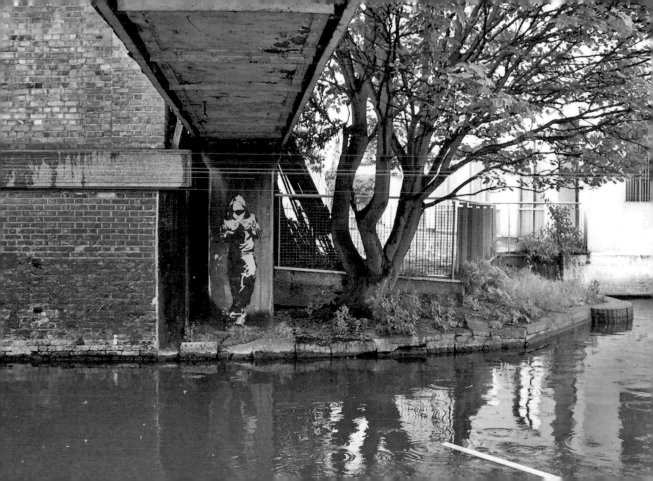

## UMBRELLA RAT

A great little umbrella rat used to live in the corner of a large whitewashed section of wall on the lovely house next to the newsagents that is on the corner of East Rd and New North Rd (postcode: N1 6JB. Map/GPS reference: TQ 32877 83049).

Before the wall was whitewashed, I think there was other graffiti there (by other writers), but only the Banksy was saved. Six months later though the whole wall was painted over.

I'll always remember a nice moment on my second free tour of Shoreditch graffiti when I was outside this building, giving the throng of over fifty people a bit of info about it. A rather hippie-fied resident of the building opened the door, in his dressing gown (it was about 2 p.m. by this point), and was slightly bemused at this huge group of people goggling at his wall.

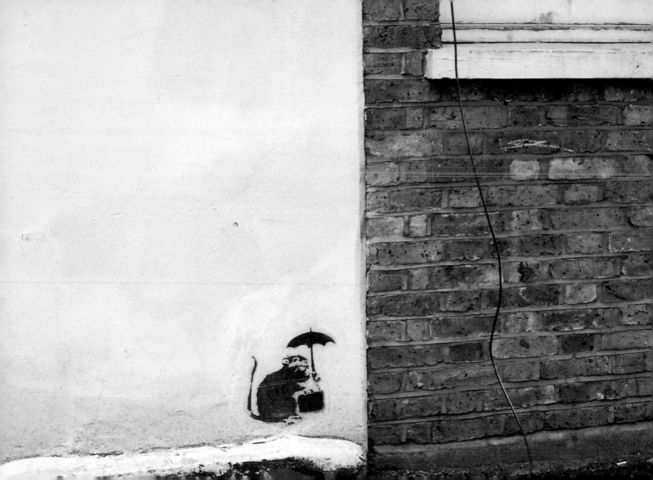

## UMBRELLA RAT

This was on the metal newsagents box of City Supermarket, 57 Pitfield St – near Haberdasher St (postcode: N1 6BU. Map/GPS reference: TQ 33014 82852).

A pretty awful specimen, with loads of runs (and therefore maybe a fake), but it was a good example of how these metal newsagent boxes are a great target for graffiti writers, because they are left out all night for secure milk and newspaper deliveries.

This was buffed, circa December 2006.

**BLT TIP:** I don't eat animal products so I can't judge the kebabs for you, but the 'Best Kebab & Café' at the bottom of Pitfield St does a lovely falafel meal, and the coffee is great too.

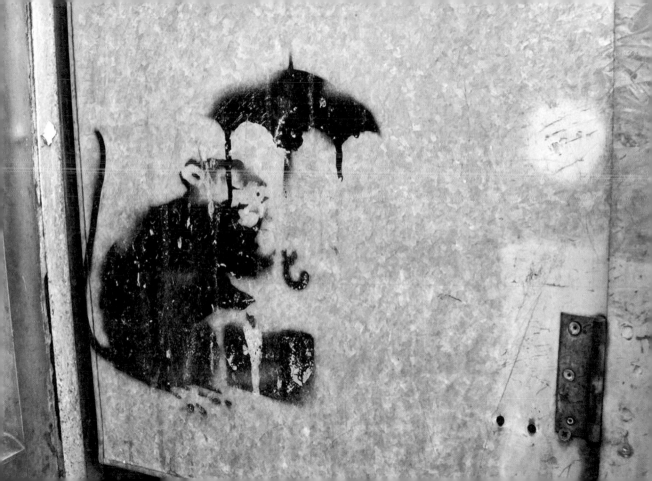

**'HAVE A NICE DAY'/HAPPY CHOPPER**
Postcode: EC2A 3JD
Map/GPS reference: TQ 32978 82519

### Location & Daring Tales of Climbing on Roofs (hardly)

Above 'Wa Do Chinese Fast Food' shop on the corner of Old St
and Tabernacle St. A large Banksy tag (with an exclamation mark,
something he only did on earlier pieces) is out of shot, to the right.
There is a great photo of this in the snow in Banksy's *Wall and Piece*
book, when it used to be Franco's Fish & Chips shop below. It dates
it to 2003.

Not long after it was done it was rather ironically obscured by
a massive advertising hoarding above it (in addition to the existing
shop sign below it). But you could climb up on the roof to get a better
look at it. Loads of painting paraphernalia is up there; maybe some
of it was used to do the piece? The image is very similar to the A2
poster given away with some copies of the March 2003 issue of the
magazine *Sleazenation*.

### Status

Still there (June 2011), but very obscured and has been mainly
covered in transparent plastic since spring 2010. It can be easier to
look at from a distance, or from buildings opposite if you can wangle
your way in.

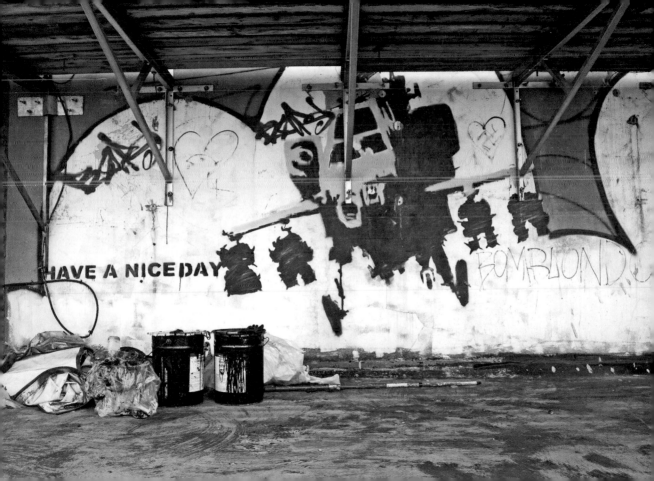

**THE FOUNDRY**
Postcode: EC2A 3JL
Map/GPS reference: TQ 33057 82557

### Location & Daring Tales of Climbing on Roofs (hardly)

Inside this eclectic Hoxton bar/venue/exhibition area (situated where Old St and Great Eastern St collide), there is a mess of graffiti on the downstairs walls, surrounding the toilets (and inside the toilets a bit. Yes, I did also check out the ladies'). Any writer who's had work displayed in the venue, or is generally good enough, was 'allowed' to add to the wall.

Banksy contributed a grin reaper, a happy chopper, and a tag. Notable others on the wall include Arofish, who had an exhibition there in the mid-2000s, and the Faile collective.

Unfortunately the future does not look rosy, as permission has been given to knock down the entire site (which includes location S13 – but that's supposed to be saved...) and build an eighteen-storey, 350-room 'art hotel' on it – oh the irony of an 'art hotel'!

### Status

Still there I believe (July 2010), but the Foundry is now closed, so the future for the art seems very uncertain.

**THE 'PULP FICTION' SITE**

This is probably the most famous site regularly used by Banksy, but it's also very hard to photograph and view. Staying further away often gives you a better view of it. It's above a row of shops on Old St, near Vine St (postcode: EC1V 9PB. Map/GPS reference: TQ 32834 82543).

From 2003 to 2005 it had Banksy's famous Pulp Fiction piece on it. It was gone over after the bombings of July 7, 2005, with a message to '**** Al Qaida'.

In May 2006 Shepard Fairey put a massive Obey poster up, and Faile flanked it on both sides with their snarling dog wheat pastes. 'Banksy was here' was then crudely added on top in a pink paint that looked suspiciously the same shade that both Faile and Banksy had recently used around town (see location F5, and the BLT Tip between F8 and F9, plus some in *BLT Vol 2*). 'TDO' (Take Down Oker) was also painted on it, so maybe it was something involving them?

Then in early July a new version of Pulp Fiction went up, with them dressed as bananas and holding guns (rather than the other way around, how the original showed them), followed in September with a complete paste-over, and then a crudely drawn message that 'Nothing Lasts Forever'. As they say, great art is all in the compositio…

Throughout the rest of 2006 and most of 2007 the wall was pretty rubbish. Every time I went to the area I always checked it out, and every time I was disappointed. I almost stopped bothering.

Fast forward. It's 5.30 p.m. on 9th September 2007. I'm on the top deck (the best seat in the house for graf spotting!) as my bus goes past the site. I half-heartedly turn to look at the wall. OMG! I jump up, ring the buzzer, and stop the bus. I'm excited not just because it's new, but because it has Banksy metaphorically written all over it (although many amazingly doubted it at first!) and most importantly because it was the first piece of graffiti for months to actual stop me in my tracks, to move me, and to make me fall in love again. The quality was amazing, and the subject poignant. For me, Banksy was back on top and the quality was saying, 'I'm the daddy'.

Interestingly it was spotted that at 3 p.m. that day the site was still shrouded in blue tarpaulin (some of which was left on the roof). This was becoming a favourite Banksy trick. To actually cover a site in tarpaulin/scaffolding; to gain the time and privacy to do a good job. Soon it was on Banksy's website, with an explanation. It was called Old St Cherub and was done shortly after several children had been hurt by the consequences of gun crime. Banksy wrote, "Last time I hit this spot I painted a crap picture of two men in banana costumes waving handguns. A few weeks later a writer called Ozone completely dogged it and then wrote 'If it's better next time I'll leave it' in the bottom corner. When we lost Ozone (Ozone – 21-year-old Bradley Chapman – was killed by a train in January 2007) we lost a fearless graffiti writer and as it turns out a pretty perceptive art critic. Ozone – Rest In Peace."

In late February 2009 it was dogged by the prolific writer 10foot, with the message 'Say No To Art Fags. R.I.P. Ozone' (the same message appeared over the B-Boy in Gillett Square, Dalston in March 2009 – see *BLT Vol 2*). The wall was blackwashed in mid-March, and finally, in late June 2009, the artist 'Mantis' took the space for his take on people with bananas and the lack of attention that Africa gets. That didn't last long, though, and the wall is likely to have changed by the time I've even finished this sentence.

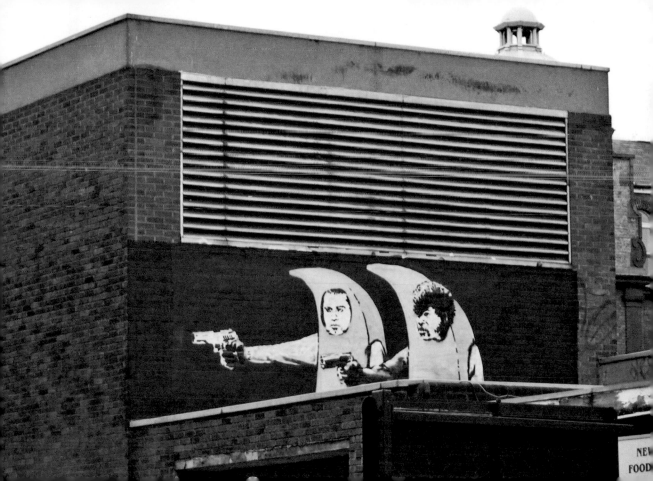

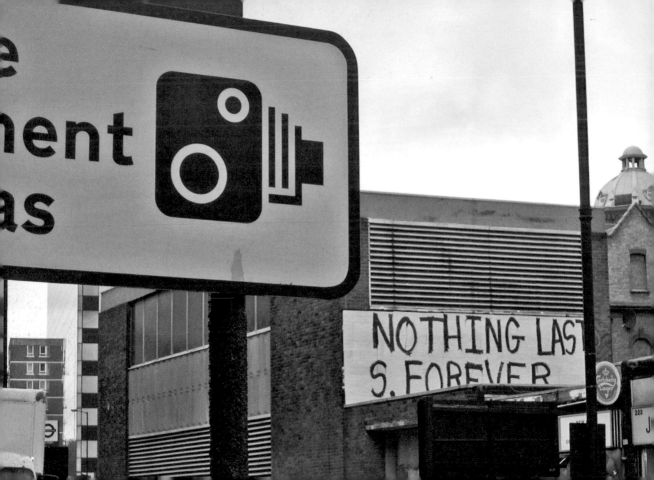

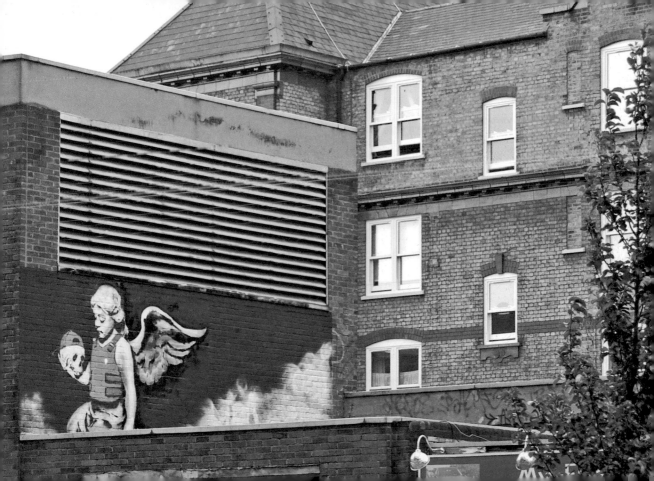

## TV OUT OF THE WINDOW & A GIANT RAT

These are technically still there, in a private car park (called 'Ridgeway Place') on the corner of Rivington St and Old St/Great Eastern St (postcode: EC2A 3DT. Map/GPS reference: TQ 33059 82549).

The wall has loads of graf on it, including Banksy's TV out of the Window (which was featured in *Wall and Piece* next to the 'Broken Window Theory' info, and dates it to 2004), and an enormous rat with a knife and fork (similar size and shape to the rat done in Liverpool for the 2004 Art Biennial – see *BLT Vol 2*).

Both have been there since 2004, and over the years an influx of other graffiti had been getting closer and closer, but in December 2007 they were covered in wooden hoardings (which were soon covered with art, mainly from the Burning Candy crew – see inset photo on the next double page), apparently in readiness for them to be removed and sold. That doesn't seem to have happened yet, as they were still definitely there, underneath the wood, in May 2011.

Its future seems just a little bit unorthodox though. Planning permission has been given to knock down the entire site (which includes location S11 – The Foundry) and build an eighteen-storey, 350-room 'art hotel' on it – oh the irony of an 'art hotel', because Banksy, Elmo, Faile, Arofish and all the others on the walls of the Foundry aren't *real* artists of course! However, Hackney Council have stipulated that *this wall* must be 'saved'. Hmm, it might be interesting to see how that happens exactly... The *Islington Tribune* reported that Banksy's reaction was that, "It's a bit like demolishing the Tate and preserving the ice cream van out the front."

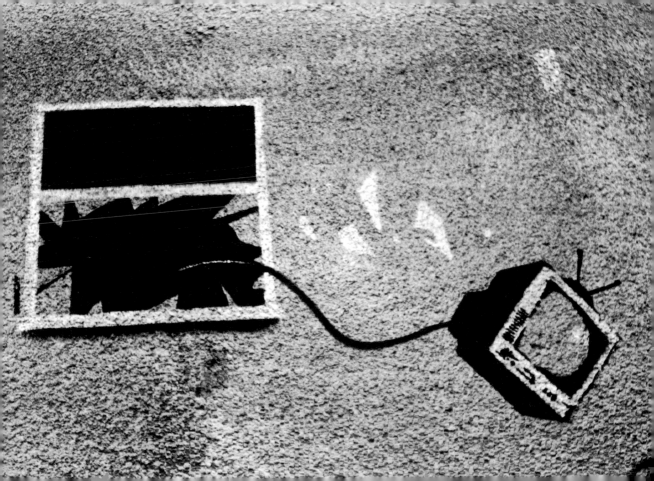

The TV out of the Window image was first seen as part of a Blur photo shoot on 24th August 2003 for the launch issue of the *Observer Music Monthly* in September 2003 (Banksy is reported to be "standing just out of shot"). Farm buildings in Yorkshire were used as the backdrop for the TV out of the Window and a giant rat photos, and the front cover shows Blur standing in front of the 'TV' artwork. It was originally supposed to be done at the Leeds Festival (where Blur headlined), but there were no walls there! And the whole thing almost fell through when, as the magazine reported, "two days before the shoot, Banksy went AWOL. It later transpired that he had been arrested in Berlin for defacing a building." So, out in the countryside they knocked on the door of a farm, and the rest is history. In June 2008, the farm owner, Stephen Walmesley, put it up for auction with an estimated value of £30,000-£50,000. It didn't sell. It probably didn't help that it was on concrete blocks and was over two metres high. Later they tried again to sell it, but I don't know what happened to it. Banksy did two others on the farm, apparently; one was a girl hugging a TV (later sold at auction in 2007 for £38,400!), but I'm not sure what the third piece was.

There used to be another 'TV' in Angel (Islington). It was on the side of an old building (since demolished) near the junction of the A1 and A501.

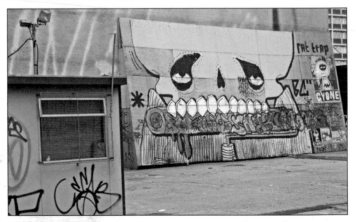

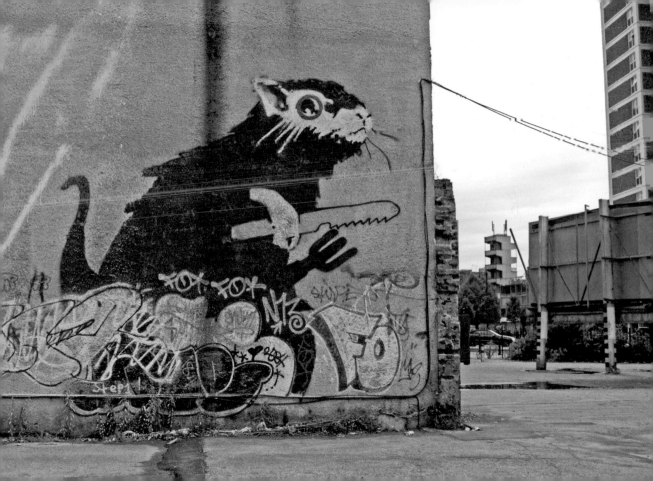

**GRIN REAPER**
Postcode: EC2A 4NY
Map/GPS reference: TQ 33003 82467

**Location & Some Information of Miraculous Accuracy (well, maybe...)**
On the side of a bar called Yard, on the corner of Paul St and
Tabernacle St.

A very faded grin reaper. Well, it has been there since 2003, so it
has paid its dues. Hardly worth mentioning, but a good example of
something that fades away, or is buffed to within an inch of its life.
It can actually just be spotted (June 2011) but it is so minor that it
would be easier and fairer to consider it a goner.

**GRIN REAPER**
A stunning yellow grin reaper used to live on a striking blue wall where the old Pictures On Walls office was (Scrutton St, near Clifton St – Postcode: EC2A 4RT. Map/GPS reference: TQ 33030 82209). It was tagged below (out of shot).

This exact piece is shown in *Wall and Piece*, which dates it to 2004, and it has also been on his website. The magazine *Design Week* also used it on their front cover on 11th March 2004, for an article called 'Peace Talks – A Visual Take on Conflict'.

Over the years it did get dogged quite a lot, and the tag got blanked out, but it survived in some shape or form until May–June 2010 when the whole wall was 'blue-washed'.

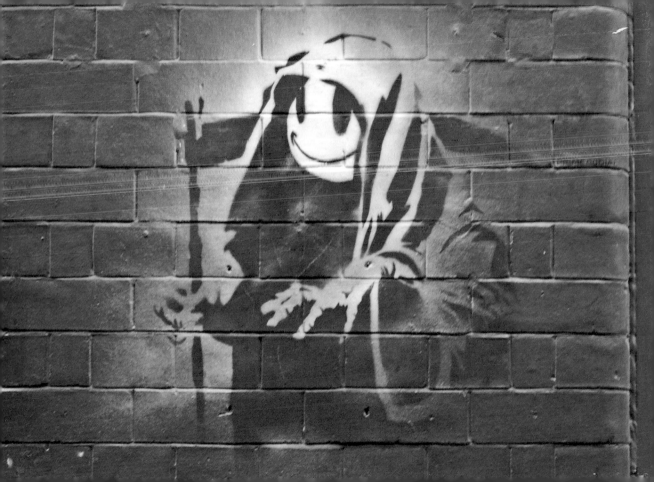

## HAPPY CHOPPERS

This used to be tucked away behind a blind corner on Holywell Row (postcode: EC2A 4XB. Map/GPS reference: TQ 33113 82180), until it was mainly painted over in about January 2007. The top of one helicopter was still visible for a while but when I visited again in September 2007 the whole alley was completely blocked off and repainted.

There usually used to be some Faile paste-ups on the building opposite, but not any more (see top inset photo – it was a sort of unofficial Faile history site that they pasted on every time they come over to London).

After the Faile posters went, a white gangsta rat could then be seen (see bottom inset photo). This is most probably a fake. I've only ever seen one white rat before (although that one was most probably real). And it seems as if this wasn't underneath the old paste-ups (if it was added after the paste-ups, then it's nearly definitely fake because Banksy hasn't done small rats in the UK for many years now).

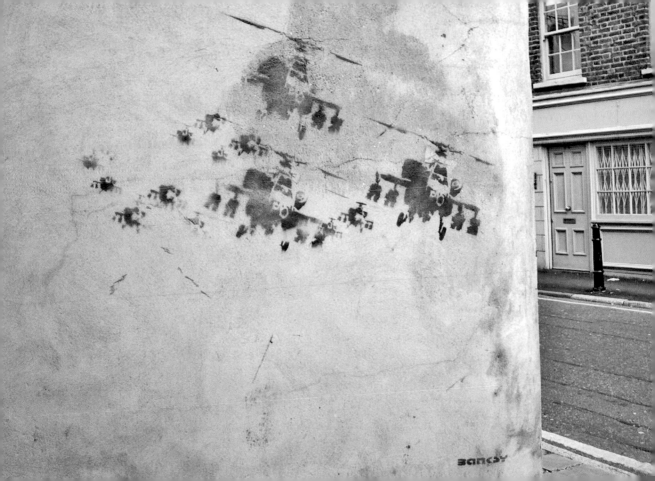

## RED CARPET RATS

This was on the corner of Curtain Rd and Christina St, by Pizza Express, and dated from at least 2004 (postcode: EC2A 3PT. Map/ GPS reference: TQ 33259 82286).

I first photographed this in January 2006 and by the time I went back a week or so later it had pretty much gone. I often revisit sites anyway, although on this occasion I was returning especially because I had stupidly lost all my digital photos from the January visit! D'oh! So for this book I've dug out a black-and-white film photo I have of it.

For some time after the rats were just noticeable, and the red 'carpet' was still quite visible on the pavement (see inset photo). Eventually more buffing meant nothing was left. You can still see the carpet (April 2010), but the wall is now black.

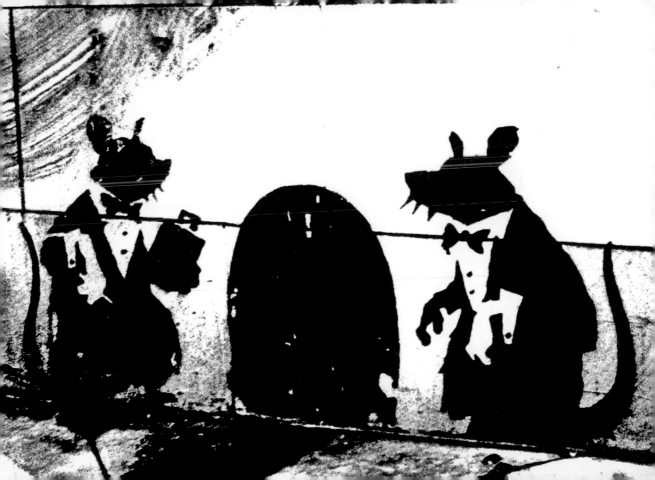

# BLT TIP

This area used to be awash with art but since 2008 there has definitely been a change of attitude from the local council (Hackney). It's still worth a wander, but in general the buffing squad, and the East London train line extension, has been winning the battle and helping to gentrify the area.

The main photo shows my second Shoreditch/Hoxton tour in the New Yard Inn area, at the blind spots around the side and back of The Old Blue Last pub. Banksy's Girl with Balloon and a soldier painting an anarchy sign had been just around the corner, but they went many years ago.

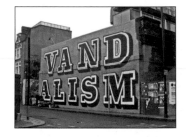

In this area Eine unleashed his new 'neon style' alphabet letters in June 2006 (see top inset photo). I think this is the best font Ben has done, and I liked it so much I bought a sweet canvas of it. In late June 2007 he blew people away with his largest piece yet; the word 'vandalism' on the massive back wall of the Village Underground, on Holywell Lane.

An unusually large Space Invader used to exist in the distance, on the old rail bridge (see bottom inset photo), until it was demolished in summer 2007.

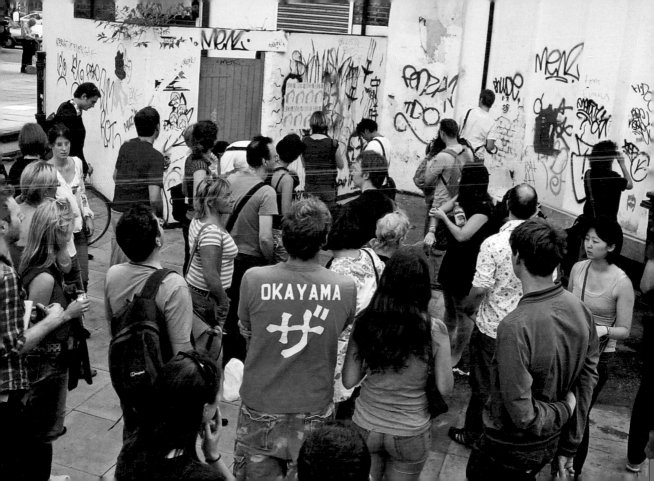

## DESIGNATED PICNIC AREAS

Two enigmatic 'Designated Picnic Area' stencils previously lived within a few metres of each other on Curtain Rd (postcode: EC2A 3AH. Map/GPS reference: TQ 33294 82478). Both had been there since at least autumn 2003.

   1) On the small steps of a building on Curtain Rd (near Curtain Place) – see the main photo.

   The was one of my favourites anywhere, as the entrance it was on used to be plastered with old posters and litter, and was definitely not a place to have a picnic. It was later slowly tarted up. In mid-2008 fresh, bright white, doors were added to the entrance, making it look a totally incongruous mix of skanky and new. Then the whole building was given a clean and tidy treatment, and finally in 2009 the stencil was gone, as it became a posh estate agent (Nelsons); the same way that many things have gone in Hoxton.

   2) On the Curtain Rd end of a skanky alley (Dereham Place). This is shown in the inset photo, not long before it was buffed in December 2006.

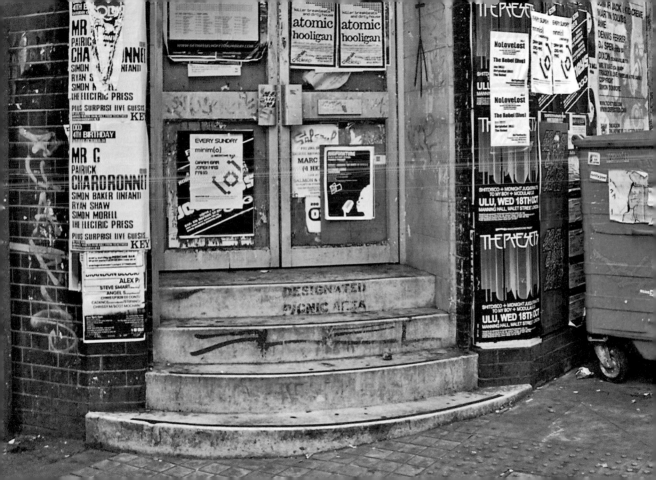

## SNORTING COPPER & WHITE LINE

The infamous snorting copper was just off Curtain Rd (by 'The Elbow Room' Pool Lounge & Bar – Postcode: EC2A 3BS. Map/GPS reference: TQ 33249 82500). The white line can still be seen (July 2010) going along the alley (Mills Court) and into a drain on Charlotte Rd.

One day in May 2006 the Council came along and badly jet washed this. Ironically it then looked far worse! (see inset photo) At least this art was making an attempt to brighten up the streets and get our brains thinking.

It was partly shown in *Wall and Piece*, which dates it to 2005. The book mixes and matches photos of this white line and the one that existed outside Waterloo train station (see location R6).

**BLT TIP:** This alley (Mills Court) often has good graffiti in it.

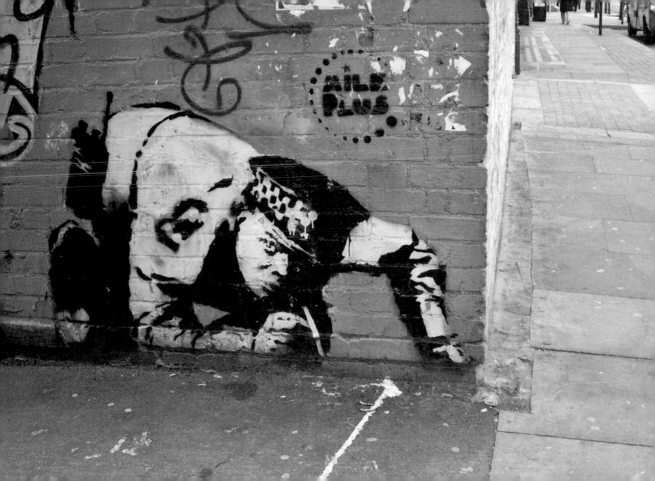

**SWEEPING IT UNDER THE CARPET ['HOXTON MAID']**
This was on the side of Jay Joplin's White Cube gallery (Rufus St side) in Hoxton Square (postcode: EC2A 3PT. Map/GPS reference: TQ 33259 82286) for about six weeks in mid-2006 before they probably decided it was too much competition for their own exhibits and painted over it.

A slightly different version also appeared in Camden (see *BLT Vol 2*). The special (RED) edition of the *Independent* for 16th May 2006 reported that, "Banksy said yesterday that the... piece was... about the democratisation of subjects in works of art. 'In the bad old days, it was only popes and princes who had the money to pay for their portraits to be painted,' he said. 'This is a portrait of a maid called Leanne who cleaned my room in a Los Angeles motel. She was quite a feisty lady'."

Both versions were based on the original street version in Los Angeles in March 2006 (just before the infamous Barely Legal exhibition, which had a canvas version of it on display). A drawing of the image also featured on his website for a while, as did a photo of it on the street.

Literally being the first to 'discover' this by stumbling across it early-ish one Sunday morning in May 2006 (I suspect Banksy did it in the small hours of that Sunday morning, the 14th) is a pleasure you can only really get by wandering around, keeping your eyes open, and following your destiny (I'm always amazed at how many weird situations have led me to come across this stuff!).

One sniffy and elitist comment about this book was that it made it too easy to find graffiti and therefore made it a common and accessible experience. Apparently finding things by wandering is called serendipity. I had to look that up in the dictionary ;-)

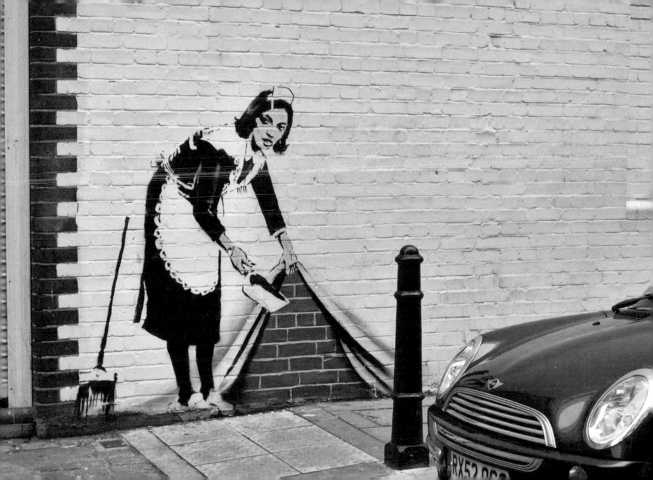

**ABANDON HOPE**

Another very iconic Banksy spot.

This was on the old train bridge across Old St, near Shoreditch High St (postcode: EC1V 9LP. Map/GPS reference: TQ 33371 82674). From 2002 Banksy regularly added pasted up images and messages to this bridge (such as 'It's a Free Country', 'Wrong War', and 'We Will Win' – painted by a rat). It's a main route to Hackney/Bethnal Green, or to the City.

The final message was 'Abandon Hope – 9am to 5pm' in early April 2006, which only lasted a week or so. This was one of the few times that Banksy used pasted-up posters, and apparently he was close to getting caught when doing it. Film of it going up was briefly featured in his film *Exit Through the Gift Shop*.

Please excuse the poor quality photo of this one (and a few others in the book!). When I started photographing graffiti I never dreamt I would be using them in books and took them on very low res, so a lot of my earlier photos are of dubious quality and even more dubious creativity (there are only so many ways you can photograph a wall, especially with my old colour point-and-shoot camera – I used to reserve my creativity for my black-and-whites.).

Bits of the old Smiley Soldiers (that had always flanked the messages) were still visible for a while after, but the bridge was completely stripped and repainted in September 2006 in preparation for the extension of the East London train line, which is now using the bridge again. But I always wonder if Banksy will be able to resist targeting it again one day!?

This slogan was later used (on a sheet of metal) at the Barely Legal exhibition in Los Angeles in September 2006. It presumably got sold, as it later turned up at a weak exhibition of Banksy artworks in New York in December 2007.

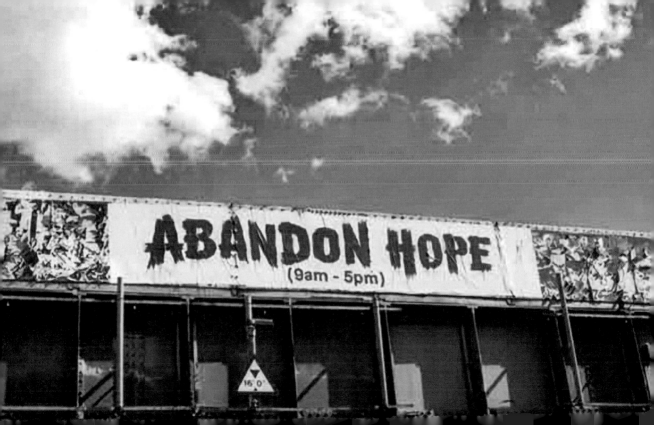

**CUTTING RAT**

This was on the metal doors to one of the 'underneath the arches' workshops on Geffrye St (postcode: E2 8EA. Map/GPS reference: TQ 33573 83118), behind the Geffrye Museum.

It was only one cutting rat this time, but because it was cutting into the padlock, it gave it a great context.

The half of the metal door with the Banksy on it was taken away in late February 2007. Wooden boards replaced it.

It later turned up in July 2009 at an awful 'exhibition' of ex-street works by Banksy in Covent Garden, London. It was badly entitled Please Love Me – Banksy and contained a large amount of what they called 'architectural' pieces (I would call them ripped off street pieces!).

Please remember that this book is *not* provenance that a piece featured here is by Banksy and can probably be sold for the price of a small house. This book is just a bit of fun and no guarantee that something is by Banksy.

**PARACHUTE RAT**
This was on the wonderfully entitled Diss St (postcode: E2 7RA.
Map/GPS reference: TQ 33712 82975) until it was buffed, circa
December 2006. It was the best and most photogenic parachute rat
around until it fell foul of a Council clean-up campaign.

Several Eine'd shop shutters exist on Hackney Rd, and the
Gorsuch Place area is usually worth exploring for graffiti/art.

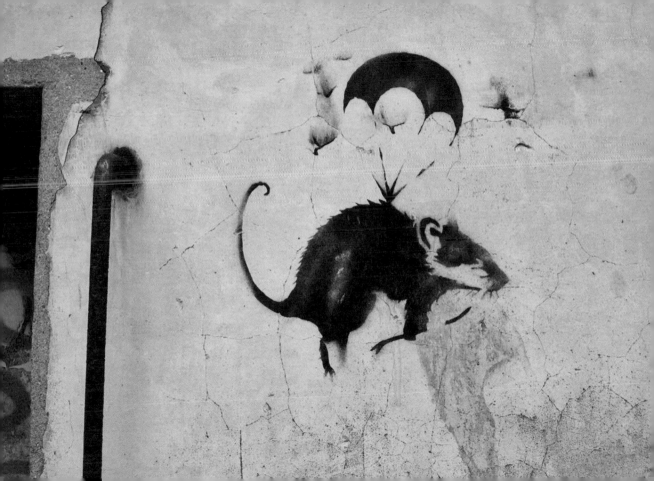

**KEEP IT REAL**

This rare little monkey lived from at least mid-2005 towards the bottom of Ravenscroft St, close to Columbia Rd (postcode: E2 7QB. Map/GPS reference: TQ 33927 82885)

There is only one rule in life. Yes, really... just one. You can never have enough monkeys.

That's it. Sorry if I have now spoiled the meaning of life for you, but you had to know sooner or later. Oh, and whilst I'm making people's lives better I'll let you into a secret: the tooth fairies don't really leave you money in return for your teeth; it's your parents.

Never the greatest graffiti (it was rather small and hence the detail was poor) but for a long time it was the only surviving example around. It was then buffed (circa December 2006). There is a photo of a similar monkey in *Wall and Piece*, but it's not conclusive evidence that this one is 'real'. We'll never totally know.

**BLT TIP:** If you like tattoos, check out the Happy Sailor Tattoo shop at the bottom of Hackney Rd (near Austin St) which used to have several personalized Banksy prints on their walls. And if you want some tattoos done also check out the Shangri-La tattoo parlour at 52 Kingsland Rd (by the rail bridge).

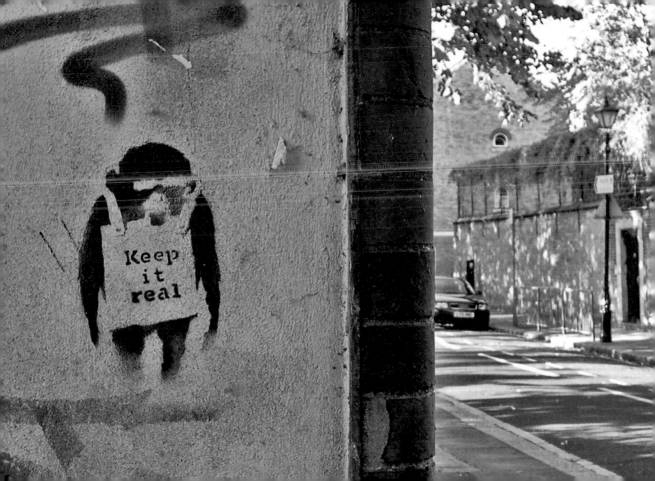

# S25

**THE 'CARGO' AREA**
Cargo – Postcode: EC2A 3AZ
Map/GPS reference: TQ 33374 82586

### Location
Rivington St, near Shoreditch High St (A10).
Cargo is often referred to as a super club, as it's so damn cool. It has pretty much supported Banksy from the start, and two of his works still remain in the back courtyard, which seems to be great respect as most of the other walls in the courtyard are rotated with new art.

Banksy has a huge amount of history with this site. After moving to London from Bristol he held his first (open-air) exhibition under the railway arch here in spring 2001, even before Cargo existed. It consisted of whitewashing part of the wall and adding twelve small pieces on top, plus the slogan 'Speak Softly. But Carry a Big Can of Paint'. Ten more pieces lived on the opposite wall. You could then order a canvas of any image. Other parts of the walls were painted with repetitive images of (a) spiky-haired cows, with earrings, and (b) billboard monkeys, declaring, 'Lying to the police is never wrong' and 'Laugh now but one day we'll be in charge'. Slightly strangely, part of one of the spiky haired cows resurfaced in late 2009, and could be seen again, next to the main entrance! It's now covered again though, by a Cargo advertising board.

Whilst these faded away, a huge couple with bright-red lips was added over part of it. Then a large 'Thug For Life' bunny was done in spring 2004. It was half-buffed in September, but an amended version survived there until about spring 2005.

And as if to mark his territory even more than an aggressive tomcat with incontinence, a huge Banksy tag was also done on the bridge above.

In the Cargo courtyard, two of those original 2001 images still exist. The Guard and Poodle (and designated graffiti area) are on

BY ORDER
NATIONAL HIGHWAYS AGENCY
THIS WALL IS A DESIGNATED
GRAFFITI AREA
PLEASE TAKE YOUR LITTER HOME
EC REF. URBA 23/366

the first wall. A few walls away (past some Shepard Fairey/Obey paste-ups; see inset photos on the previous page) Banksy's HMV image remains, although for many years it has been surrounded by other graf from Stylo of the VOP crew — check out www.vopstars.com (Nipper, the dog the HMV logo was based on, was from Bristol, so maybe there's also a connection there…)

The courtyard is open — for free — when the club isn't charging for entrance to the main club, although since they added wooden decking and loads of greenery in mid-2006 the walls are now harder to see and photograph.

## Status

Still fine (May 2011), although in March 2007 both the Banksys in the Cargo courtyard were covered with perspex, reminiscent of the sanitised 'street art' at the Old Truman Brewery. The greenery is also growing rather wild in front of the guard and poodle.

### A mention of two (relatively recently) buffed pieces…

Just outside the club entrance, a slightly forlorn 'kid with paint brush' lurked under the railway bridge (see photo overleaf; now the site of Eine's gobsmackingly fantastic 'Scary' piece) until badly buffed in November 2006. Of the four times this image was used in London in May 2006 (see the *BLT* Tip between F8 and F9 for one, and *BLT Vol 2* for the other two), this one seemed to be the least finished, and in the least well chosen environment. I wonder if it was a job rushed or half finished…?

Finally there was a 'Designated Picnic Area' and arrow in an alley (Standard Place) a stone's throw from Cargo (postcode: EC2A 3BE. Map/GPS reference: TQ 33363 82594). It was there since at least September 2003 and originally pointed to a circle on the floor. The chrome and black dubs that surrounded it actually enhanced it in my opinion. A close-up view is shown over the page, and a context shot (complete with abandoned sofa) can be seen next to 'The Geeky Bit' at the start of the book.

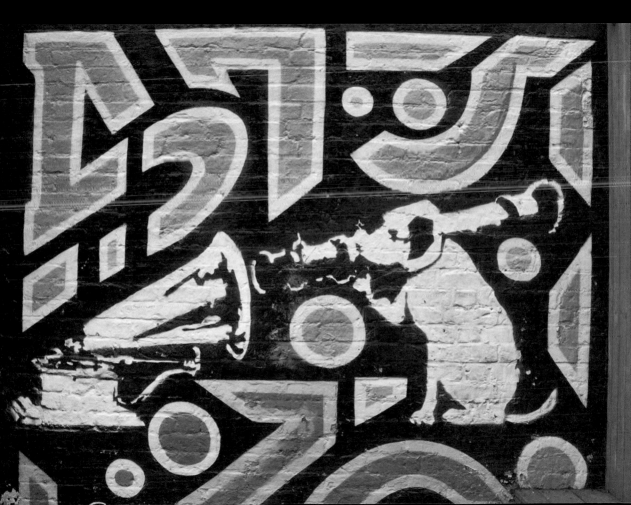

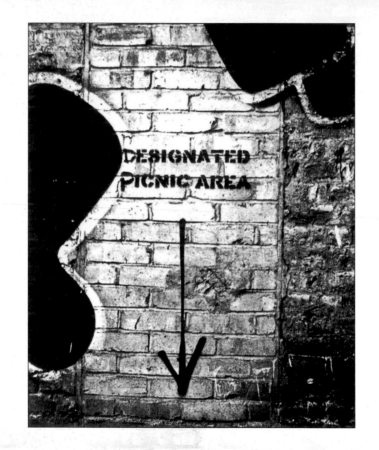

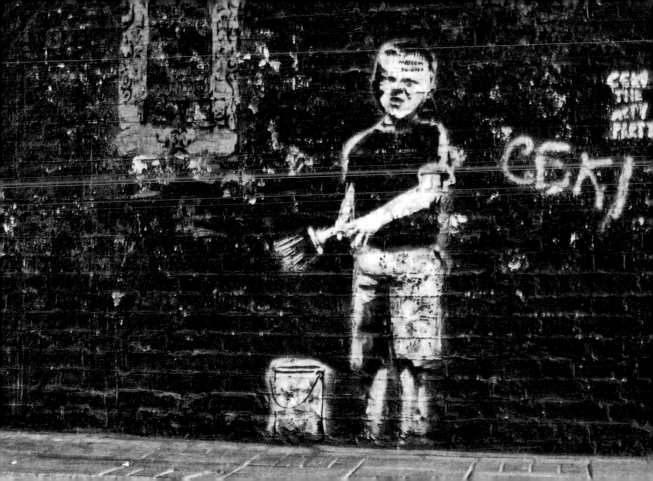

## BANKSY TAG

This used to be on the Turville St side of 'Anisha Cash & Carry', on Redchurch St (postcode: E2 7HX. Map/GPS reference: TQ 33741 82409)

By the time I took my photos of it only the Banksy tag survived (inside the utilities box), but the reason the tag was there was because a lovely sawing rat used to exist just above the box. Have a look at Banksy's *Existencilism* book to see what it looked like before. A photo of it was also briefly featured in his film *Exit Through the Gift Shop*.

I thought it had been painted over in early-ish 2008, but later it seemed as though the box has actually been removed, and that what I saw was a new box. How can I deduce this? Well, in January 2009, the box was offered for sale on Gumtree, the popular Aussie/ Kiwi/Saffa/Hippie layabout website (and it had apparently been on eBay before, although I didn't see that). The cheeky monkey even referenced my book as some sort of provenance (see the early pages of the book for my rant about people who do that!). However, being in my book doesn't mean it is by Banksy. Only he can positively confirm or deny that, and quite rightly he will not. So there is no real provenance for street pieces. They belong on the streets.

The whole side wall was covered in some sweet graf by Probs and Kause in Oct 2009 (see bottom inset photo). It was presumably commissioned/allowed, as it's such a top job.

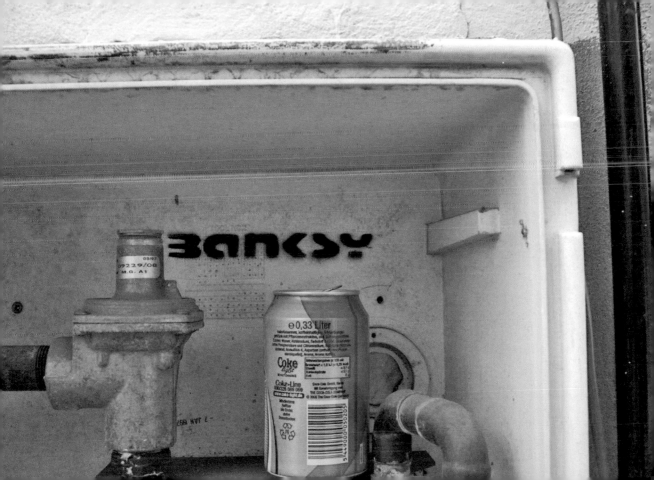

**PARACHUTE RAT**
This was on the side of an old building on Sclater St, on the junction with the Bethnal Green Rd (A1209) (postcode: E1 6HT. Map/GPS reference: TQ 33733 82291)

When it was originally there in 2003 the wall was fresh. Since I took this photo in 2006, it remained as a slowly fading rat for many years, sometimes hidden by the overgrowth. Sometime in 2009 it was finally painted over.

There is an ever-changing gallery of street art along the semi-legal walls of Sclater St, often including large pieces by one of my favourite writers, CEPT (see inset photos for just two examples of his work).

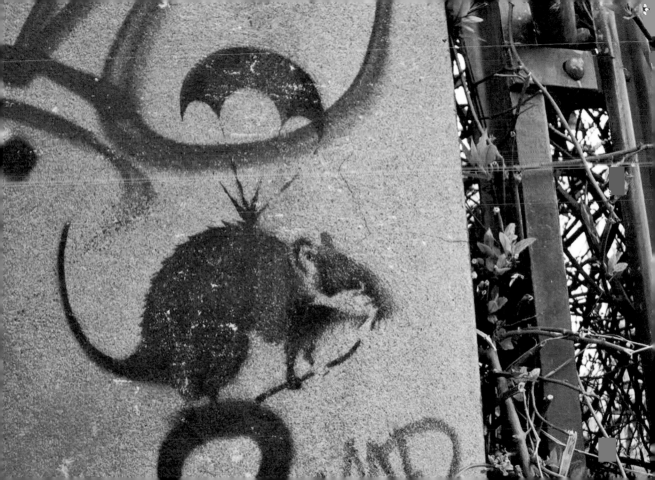

### PARACHUTE RAT

From at least early 2005 a good parachute rat existed amidst the gallery of street art and market shops along Grimsby St (postcode: E2 6ES. Map/GPS reference: TQ 33930 82233). Tentacles were added to it in spring 2006 by a person unknown, and by the autumn of the year it had almost all disappeared (see the bottom inset photo).

The whole side of the street was then boarded up in 2007, for work on the extension to the East London train line, and the whole caboodle was demolished in early 2008, never to be seen again.

Don't be fooled if you see old photos (like the top inset photo) of a small Banksy tag on the wall further down the street. The large alien/baby figures that used to exist nearby were *not* by Banksy. They were by Mr. Yu, a Japanese artist. The tag apparently related to a Banksy piece that used to be there. I didn't see the wall when it was there though and have never managed to find out exactly what was there.

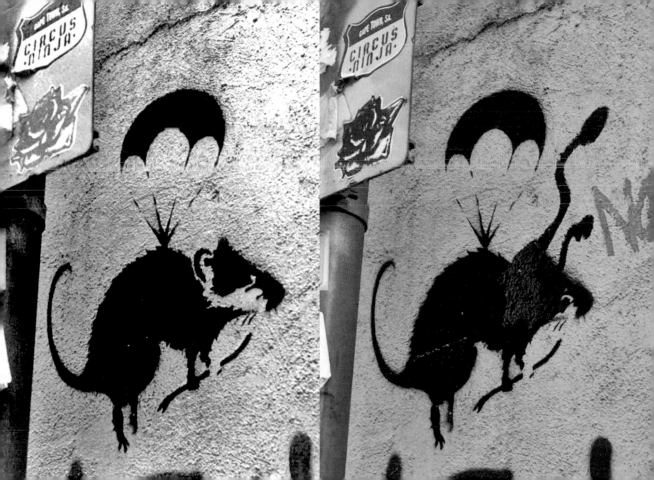

**TO ADVERTISE HERE CALL 0800 BANKSY**
This was towards the north end of Brick Lane, by the old (now closed) Shoreditch tube station (postcode: E2 6ES. Map/GPS reference: TQ 33911 82220).

This exact graffiti is shown in the *Wall and Piece* book, and had been there since at least late 2002. Seeing this in the flesh was a great sight whilst it lasted (with Eine's version opposite – see inset photo to the right). When in this area be careful of the achingly stupid-looking Shoreditch fashion victims and the Sunday street sellers.

It all went downhill when they started the extension to the East London train line. In March 2007 a temporary bridge was placed over both the hoardings (i.e. Banksy and Eine) and the two wooden boards that contained 'ban' and 'ksy' quickly went missing. Most of the rest of the Banksy piece followed soon afterwards!

Part of this (just the 'Banksy' bit) later turned up in July 2009 at an awful 'exhibition' of ex-street works by Banksy in Covent Garden, London. It was badly entitled Please Love Me – Banksy and contained a large amount of what they called 'architectural' pieces (others would call them ripped off street pieces!).

**BLT TIP:** Unfortunately this area has been really tidied up since the book first came out, but the wall down to the old tube station is sometimes still worth checking out.

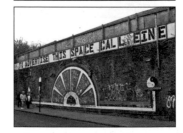

**CCTV POLE**

This was on Brick Lane, opposite the side entrance to the old Truman Brewery (postcode: E1 5HD/Map/GPS reference: TQ 33893 82003)

Banksy hit several CCTV poles around London, putting up plastic rooks holding pirate flags & cigarettes, and pulling at fake electrical wiring. How do I know they are rooks? Well, as we say in the sticks, 'If ye sees a rook, that be a crow. If ye sees lots of crows, thems be rooks'.

A Banksy tag existed on this pole, so I imagine that this was one of those sites at some point in the past. A very similar situation exists at a CCTV pole on Tottenham Court Rd, where a Banksy tag still exists, but nothing else.

A small canvas of birds pulling at wires on a CCTV pole was on sale at Santa's Ghetto in 2003. In July 2003 a similar image was done by Banksy for the cover artwork of a *Badmeaninggood* compilation (Vol 4, by the Scratch Perverts on the Ultimate Dilemma label – Cat No. UDR CD 021 (CD), UDR LP 021 (Vinyl) – pretty hard to find these days...)

For many years the tag survived without any rooks on the pole, smeared all over with 'anti-climb paint' (oh, the irony!), but even that was eventually painted over some time between November 2010 and May 2011.

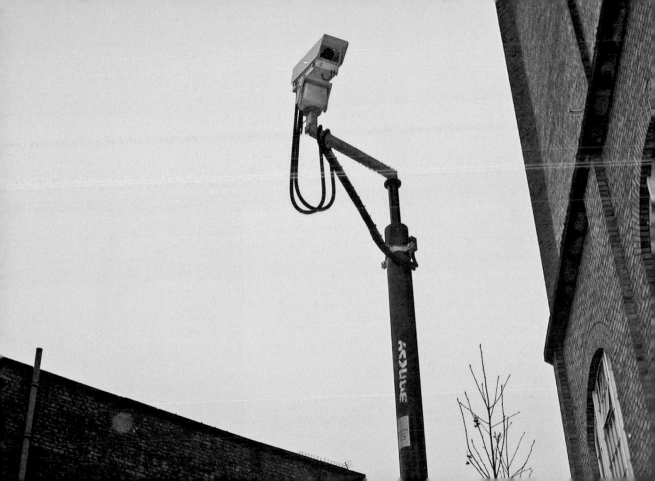

### GAS MASK GIRL

Postcode: E1 5HD
Map/GPS reference: TQ 33895 81983

### Location & Various Padding Out

This has been on Brick Lane, on the corner with Woodseer St, since
at least 2003. Note the very faint 'Banksy' tag by the right foot.

A rather surreal 'woman' playing a violin (with a happy chopper
in a thought bubble – as you do – I always dream about war when
playing the violin) used to be just a few metres away along this wall.
About a hundred metres away (on the massive wall opposite the
other entrance to the Old Truman Brewery – i.e. Hanbury St), a faded
grin reaper used to exist. By the time I took the inset photo in early
2006 it was already almost dead. It faded away totally over the next
year.

### Status

Extremely faded and often attacked by the remnants of fly posters
(June 2011), but it's the only example I know of in the UK, so it might
just be worth a visit if you are desperate.

# S32

**PINK CAR & DEATH DRIVER**
Postcode: E1 5HD
Map/GPS reference: TQ 33893 82003

### Location
On top of an old shipping container, in the main concourse area of the old Truman Brewery yard. A photo of it is shown in the *Wall and Piece* book.

I've never quite found out the reason for this, but an old Triumph Spitfire GT6 was given a Banksy treatment. A good photographic history of the site exists on the Banksy group on Flickr. An orange car existed there since at least April 2004, and sometime in late 2004 or early 2005, Banksy did his paint job on it. A Banksy tag still exists on the far right of the container. Many photographers make sure they get the 'Gherkin' in the background if they take a photo of this. I'm more of a realist so I preferred to get the skanky derelict alchy/graffiti/drugs den in the background. It's on Grey Eagle St but has since been locked up.

In February–March 2008 the window from the car disappeared. A piece of wood covered up the hole. Apparently it was smashed, rather than stolen. But it had also been seen several years before without the window, so I'm not sure if on that occasion it had also permanently gone. So maybe the most recent one was actually the second version anyway? I'm confused. I can see biscuits. I can fly! Nurse, empty my potty please…

Pieces by Space Invader, Dscreet, and Shepard Fairey/Obey, plus D*face's car (see inset photo), can often also be seen in the old Truman Brewery yard, or just outside it.

### Status
Still there (June 2011). But since November 2006 it has been covered with a horrible see-through box!

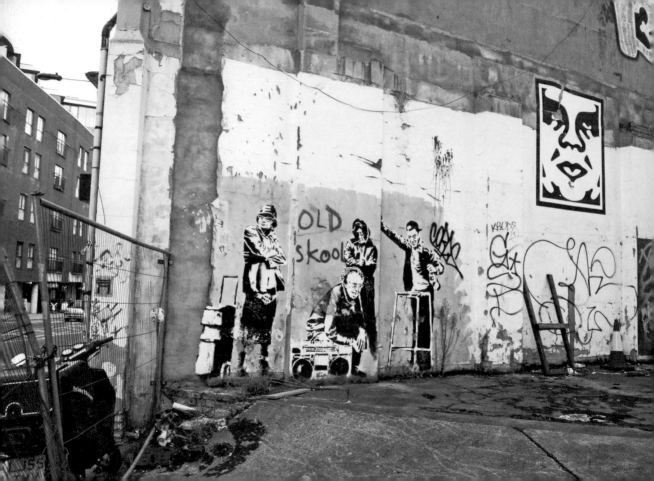

# FARRINGDON & CLERKENWELL

This mini-tour (it took less than two hours) went around the Barbican/Smithfields area, then headed up to Clerkenwell, Hatton Garden, and finally Farringdon Rd and Exmouth Market, ending up by the enormous Mount Pleasant sorting office. At the time (I did this free tour for the public in mid-2006) the tour included loads of excellent-quality rats (especially in the Barbican area that I call 'rat city'), the Cash Machine and Girl, Thugs for Life (or 'old skool' as some know it) and two enormous Blek Le Rat pieces. Over the years most have gone, although several do remain and are well worth the visit if you can.

Since the tour was run, and *BLT* was published (up to the third edition), a new Banksy arrived relatively close to the original start of the tour. So for this improved edition, I added the 'ratapult' into the book, as location F1. And just as I finished the book, I revisited it and found that it had now gone!

I've also scabbed a rare photo of the Bomb Hugger (location F6) off a kind lady.

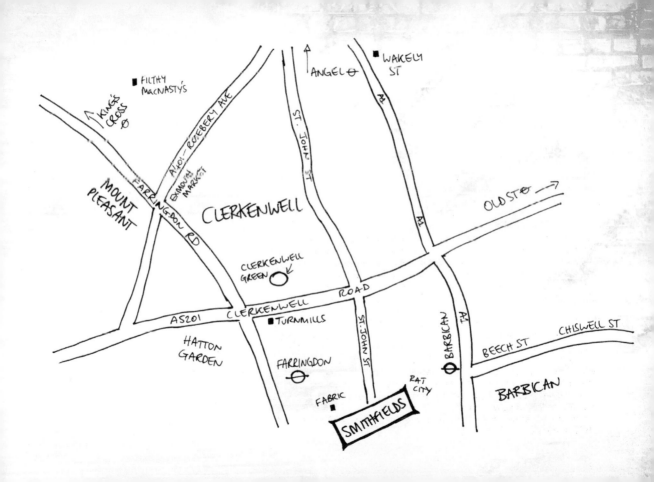

**RATAPULT**

Until recently this was on the wall outside the 'East House' Chinese takeaway on Whitecross St, London (near junction with Roscoe St – Map/GPS reference: TQ 32382 82250).

A man at a local business confirmed to me that this was not there late in the evening of Saturday 8th September 2007, but was suddenly there by early next morning. It was one of three new pieces that went up in London that weekend (the others were the 'Old St Cherub' – location S12 – and the Portobello Market version of 'Nob Artiste' – see *BLT Vol 2*). Over the following days, weeks and years, several additions were made to the wall (including the red 'target' lines and the wavy black line in my photo of it, which was taken just a few days after it was done), but none seriously detracted from the piece until one pretty large one on the right-hand side in April 2009. Then in mid-April '10foot' continued his dogging spree of Banksy pieces with a throw up between the rat and the cat, and after that it got regularly hit, added to and then cleaned up.

Sometime between March and June 2010 the wall was totally whitewashed, and a dainty little wall garden was built in front of it. Goodbye rat, hello shrubbery :-)

The photo of it on Banksy's website calls it 'ratapult' and it was accompanied with the following text: "RAT FACT – In London you're never more than 20 feet away from somebody telling you you're never more than 20 feet away from a rat."

**PLACARD RAT – 'LONDON DOESN'T WORK'**
Postcode: EC1Y 4SB
Map/GPS reference: TQ 32497 81970

### Location
Chiswell St, near Lamb's Passage.

This is a brilliant example of Banksy's placard rat, this time announcing that 'London Doesn't Work'. A photo of it was briefly featured in his film *Exit Through the Gift Shop*. It's been there since at least mid-2004 and was one of the most popular black-and-white photos that I sold. In a stroke of genius I took my original photo of it with a London taxi going past (surely one of the iconic images of London – not that I'm saying taxi drivers are what makes London not work – Terry 'The Knuckles' Wilson wouldn't let me say that and nor would my dear departed dad, who was a taxi driver for much of his life).

Unfortunately it was a silver taxi and not the black version! Tough. Take your own photo if you prefer, clever clogs :-)

In late February 2010 the placard was amended to read, in chunky black marker pen, 'I Love Robbo', presumably as part of the fallout from the now infamous 'Robbo' incident (in December 2009 Banksy amended/went over a very old piece by veteran writer Robbo on the Regent's Canal in Camden, and all hell broke loose afterwards). Shortly afterwards it was amended again to 'I ♥ London Robbo'.

### Status
Apart from the (Team) 'Robbo' addition, it has had a surprisingly small amount of dogging around it, and still looks good (June 2011).

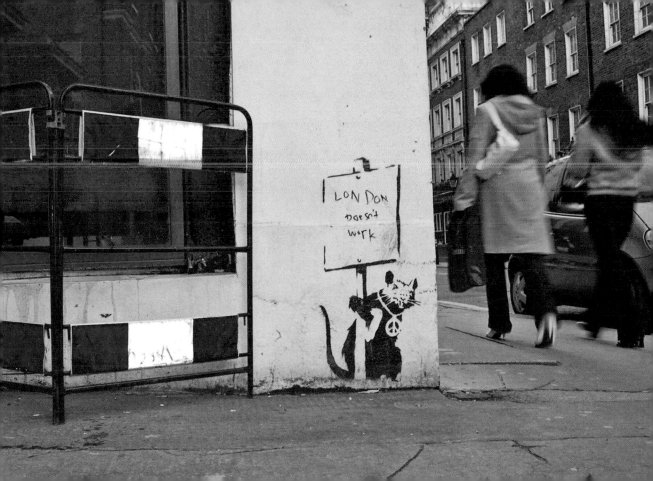

**FADED PLACARD RAT**
Postcode: EC1A 9HF
Map/GPS reference: TQ 32065 81844

### Location & Anything Else I Can Think of (without trying too hard of course...)

On Long Lane, just around the corner from Barbican tube station.

A very faded placard rat. Hardly worth mentioning, but a good example of how this one (on the main road) was buffed early on to within an inch of its life, whereas the gaggle of rats (or litter, or gang, or parliament, or whatever it is...) around the corner (see F4) were treated as preserved works of art for many years!

### Status

Hard to see, even if you know where it is (May 2011).

# F4

**THE RAT PACK**

These four all used to be within twenty metres of each other, on Hayne St and Charterhouse Square (postcode: EC1A 9HG. Map/GPS reference: TQ 31941 81847).

Banksy obviously had a bit of a mentalist moment in the Barbican area one night. Within twenty metres, four different stencils adorned the walls. B, C and D (see photos) were all on the same building on Charterhouse Square and when it got repainted (twice – first pink, and then white) they actually painted around the Banksy pieces, thus preserving them a little while longer (see inset photo of the gangsta rat). The 'Go Back to Bed' placard rat was on Hayne St and it spoke very personally to me when it told us to go back to bed. Very sound advice! I'm more of a no-getter than a go-getter.

The other placard rat was originally without a slogan (circa early 2006). Then 'welcome to hell' appeared on it. The body of the rat later had 'Go back to Bristol boy' scrawled onto it by a person unknown (see final photo). The red '4' stencil on top seems to have been a viral advertising thingy for 'Resident Evil 4'.

Three of them (not the Bling Rat) are shown in Banksy's books.

Two of them ('Go Back To Bed', and the Bling Rat) were painted over in December 2007. Then in January 2008 I received an anonymous email telling me the other two (Gangsta Rat and 'Welcome to Hell') had been "surgically removed from the wall and replaced with fresh plaster". These rats were dying like flies (if that isn't a mixed metaphor).

It wasn't until November 2009 though that a slightly crazy story emerged (in *Vice* magazine) about the incompetent theft, and resultant destruction, of the gangsta rat. If the story is true the phrase 'surgically removed' suddenly becomes rather funny/painful. This one was my favourite gangsta rat in London, and was the same stencil that was used for the official screenprint from Pictures On Walls (POW).

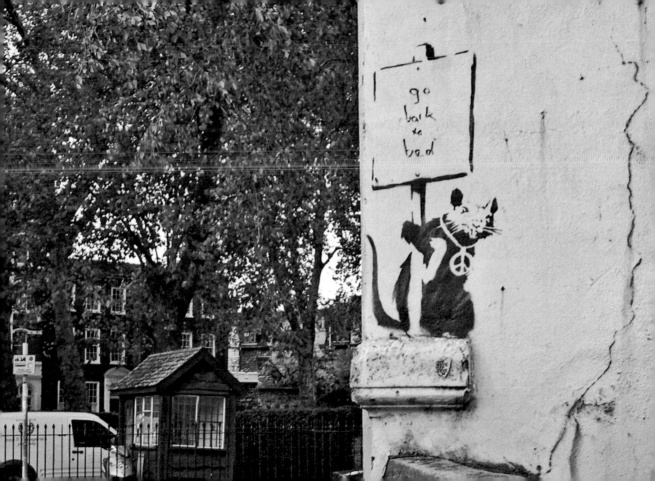

**BLING RAT:** This one is a slightly different take on the gangsta rat. I've called it Bling Rat because it has a massive necklace on, and music booming from the ghetto blaster. Offices loom behind, and will probably be complaining about the noise very soon.

GO BACK
TO
BRISTOL
BOY

## FAILE – STENCILS

Two fantastically detailed stencils ('Smoking' and 'Monster') were in Lindsey St on the wall of an old 'men's lavatory' opposite the East side of Smithfields market (postcode: EC1A 9HL. Map/GPS reference: TQ 31943 81802)

I spotted these early in June 2006, but they might have actually been part of the Faile blitz in late May 2006 when the Faile collective plastered Shoreditch with various examples of their name, and snarling dog wheat-pastes.

At this time Faile still possibly just about numbered their original collective of three people; a Canadian man, an American man and a Japanese woman, operating out of New York. Around this time Aiko left, but the two Patricks (i.e. the men) continued on. For more info see www.faile.net

A very bad attempt was made to buff it in early 2007 (see inset photo).

MEN'S
LAVATORY

SMITHFIELD
Goods
vehicles
loading
only

At any time

13¢ GIVE HIM SOMETHING TO REMEMBER YOU BY!
SMOKING SILENCE
LOVE & DEATH!

BURNING LOVE
GIRL! IT'S ALL ABOUT FATE!

CAPTIVATING STORIES OF LOVE
38¢
FEAR MADE HIM A
MONSTER

FAILURE
MADE HIM A MAN

## BOMB HUGGER
Map/GPS reference: TQ 31709 81783

### Location & Possibly Helpful Padding
Inside Fabric club, 77a Charterhouse St, EC1M 3HN.

For all you drum 'n' bass heads out there, a night out at Fabric will not only make your jinglies jangle, but you can also check out a Banksy Bomb Hugger sprayed straight onto the wall, by the toilets. They even put a frame around it!

### Status
Still there, I presume? I'm too old for Fabric now, I reckon...

# BLT TIP

On your way up St. John's St (between locations F7 and F8) you used to be able to check out a large road sign that had large Obey and D*face paste-ups on it (see inset photo, left), but the whole sign was removed in early 2007. You can still just about glimpse a large Blek Le Rat paste-up (see inset photo, right) inside an old empty shop on the east side of St. John's St, approx opposite Aylesbury St. An even more enormous Drummer Girl canvas (official title = 'Resist Against the Imposters') existed in the clothes shop next door but in late 2007 I noticed that the whole shop had closed down, and the Blek canvas had gone.

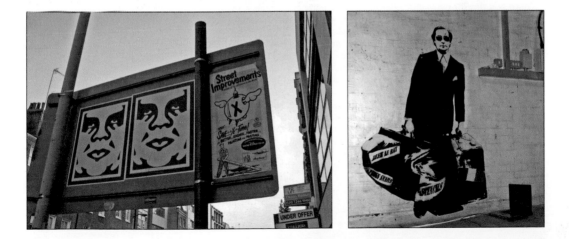

## GANGSTA RAT

This was at floor level, near some railings on Peter's Lane (just off St. John's St) (postcode: EC1M 4BL. Map/GPS reference: TQ 31772 81903)

Yeah, yet another rat, but another good quality one and a very ironic addition to it. Someone has written 'not a Banksy' on it, when in fact it looks like one of the clearest Banksys around. Sure, they can be faked (and there are some questionable ones out there), but I doubt this one was. And it had been there since at least 2004, which at least firmly put it in a timeframe for possible authenticity (rat stencils haven't generally been done by Banksy in recent years, and newish ones are therefore usually fakes).

Repetitious images of a woman's face were added to the right of it in early 2007, and later in the year various other daubs were added, including a supporting comment that it was 'a proper Banksy'! The wall was completely whitewashed in mid-March 2008. There are even photos on the Banksy group on Flickr showing workmen whilst they did it. Now you are more likely to find a pool of Friday-night sick where it used to be.

The buildings on the opposite side of St. John's St were used as the Trans-Siberian restaurant in David Cronenberg's excellent 2007 film *Eastern Promises*. One of Eine's shop shutters in Broadway Market (Hackney) was also featured in the opening scenes of the film.

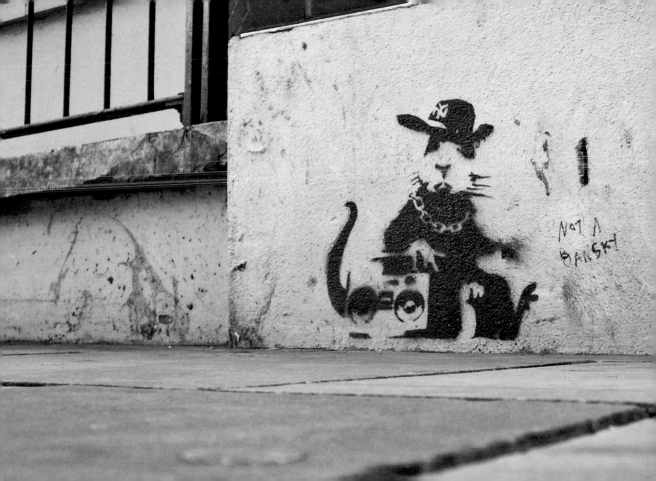

## REFUSE STORE HANGING RAT

Previously at the bottom end of Agdon St (just off St. John's St/
Compton St) (postcode: EC1V 4JY. Map/GPS reference: TQ 31688
82363).

I loved the placement of this likkle rat, hanging off a door marked
'Refuse Store'. The metal door gave photos of it a grey tone, but
if you play around with the image you can also get it into a nice
contrasty black-and-white image.

The rat looks exactly the same as several images of these rats in
Banksy's various books. When I walked past in the pouring rain in
early January 2008 (the things I do to update this book!) I noticed
the whole door had gone, and a wooden door had been set up behind
the original metal door (see inset photo below; photos I saw later on
the internet suggest it might have already been gone by November
2007).

Shortly after this happened I wasn't far wrong when I speculated
in the third edition that this might soon be on sale on eBay. It actually
turned up at the Contemporary Art auction on 27th Sept 2008 by the
previously well respected Scottish auctioneer Lyon & Turnball.

This was one of their first ever auctions in London, and the first
to contain lots of graffiti/street art. It controversially contained
five Banksy street pieces, all allegedly authenticated by Vermin, a
company that 'authenticates' Banksy street works even though they
have no input from Banksy, Pictures On Walls or Pest Control (the
company given permission by Banksy to authenticate his work).

I was very, very unhappy when a friend told me that they had
referenced this book in their sales description of the piece. I rattled
off a complaint to Lyon & Turnball, but they refused to take out the
reference. My follow-up emails went unanswered (not surprisingly,
especially as the third one was childishly smug that their auction had
been a colossal flop).

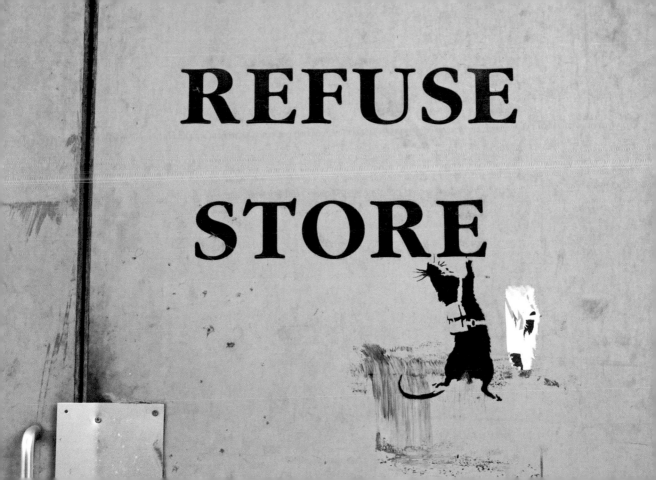

My argument went like this (almost verbatim)... 1) you use my book as some sort of claim to give provenance to your piece. You cannot deny this. My book was not meant for this. It was meant as a reference book and DIY guide. It was not a sales catalogue, nor a map to find what pieces to steal, take to auction or buy from the owner; 2) you are selling a street piece and trying to make a huge amount of money for it; 3) you are using Vermin as some sort of provenance for your piece, when they actually know little. Banksy and Pest Control are the only people that can provide provenance, and they will not give provenance on street pieces... because... they don't want to! Is that an accident? No, it's because street pieces are meant for the street. Are you getting the message yet? Most people do not want to see street pieces being sold by auction houses.

Compare the following news stories to see how they started off so bullish (especially about the use of Vermin) and ended up with 80% of the lots failing to sell:

http://news.bbc.co.uk/1/hi/scotland/edinburgh_and_east/7596740.stm
http://news.bbc.co.uk/1/hi/entertainment/7638493.stm
http://news.bbc.co.uk/1/hi/entertainment/7641966.stm

The estimate price was £20–25,000, but it remained unsold. I feel vindicated to some degree.

This story still had a few twists up its sleeve though. After failing to sell, it then turned up for sale at Bankrobber Gallery. At least we finally got some clarity about Vermin though, as their website (which was shared with Bankrobber at this point) now stated that, "From 2009 Vermin recognizes Bankrobber as the only commercial outlet for Vermin certified works", and several street pieces were being openly offered for sale by Bankrobber.

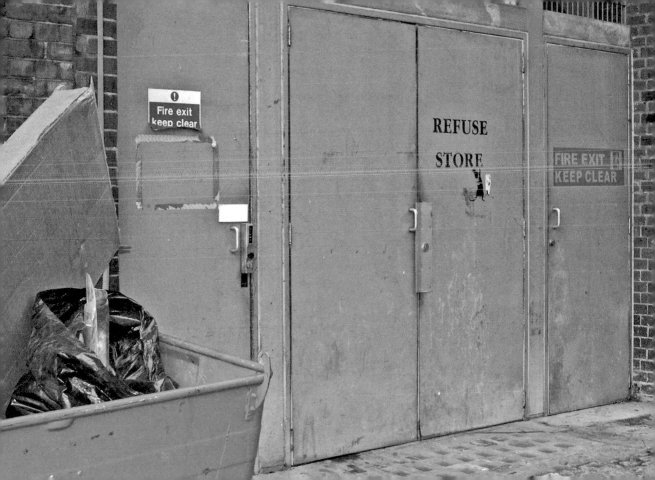

# BLT TIP: BANKSY vs FAILE

This was originally in *BLT* only as a detour, because it was a fair old poke off the normal tour. It was on Wakely St (A501), by the corner with Goswell Rd (postcode – EC1V 7RQ) and was not only another great example of Banksy's 'kid' stencil, which he used at least four times in London in May 2006 (this time he is painting a heart on the wall), but also a great Faile stencil ('Fate') and a classic view of 'dangerous' urban decay in an otherwise gentrified area.

In January 2008 both were boarded up and the Banksy was offered for sale on eBay. The Faile would graciously be thrown in for free, rather like a fart in a small room. The seller said that the building was being developed, and that he had permission to sell it. They also wrote that, "This is a once in a lifetime chance to rescue and own a part of the real London", which is surely irony if I ever heard it. Bidding finished at £8,100, but that didn't meet the seller's reserve.

Both remained heavily boarded up for a long time, but the Banksy one at least must have finally been taken off the building, as it turned up in July 2009 at an awful 'exhibition' of ex-street works by Banksy in Covent Garden, London. It was badly entitled Please Love Me – Banksy and contained a large amount of what they called 'architectural' pieces (I would call them ripped off street pieces!). It was later being touted by Bankrobber Gallery (see F8 above for a similar story). I hate giving them publicity, but I do have to document what has happened to this piece. Please remember kiddies that this book is *not* provenance that a piece featured here is by Banksy and can probably be sold for the price of a small house. This book is no guarantee that something is by Banksy, and it's supposed to help fans of his work find them, rather than help frustrated buy-to-let landlords to make an even quicker buck.

If you are in the area and are thirsty you might like to stop off at Filthy MacNasty's, a well known pub, at 68 Amwell St, EC1. It's covered with music memorabilia, including some of favourite son Pete Doherty, whilst with The Libertines, and plays an eclectic mix of music. Lenin reputedly drank here in 1905. He's probably not been back for a while though.

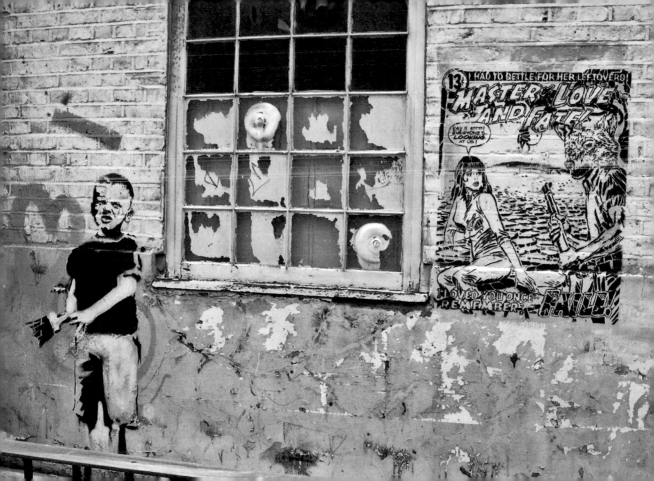

## PAPA'RAT'ZI
Postcode: EC1R 0DY
Map/GPS reference. TQ 31494 82185

### Location & tales of Smarties & Alcohol
At the south end of Clerkenwell Close (i.e. close to Clerkenwell
Green).

Strangely tucked away on the side of some flats where few might
be expecting to see this photographer-cum-rat. One time when I
was checking its status and taking a few new photos of it, I met the
woman whose flat is beside it. She was amiable enough, but said she
was sometimes disturbed by the attention it got, at all hours of the
day and night. I didn't have the heart to tell her that I had written a
book telling people where it was!

Note that the 'Banksy' tag is on backwards. A little bit of alcohol
can obviously make for a fun evening? :-)

A reader kindly told me in October 2008 that it was still there, but
that it now had about 6 blobs of bright coloured paint surrounding it.
Strange. It looked like a tube of Smarties had exploded over it. The
colours have faded though, so it's definitely more mellow now.

### Status
Fading, but still there (June 2011).

**BLT TIP:** Banksy's 'Justice' statue was
famously unveiled to a scrum of people on
Clerkenwell Green in August 2004. Nothing
survives today though. The statue was a modified
version of the statue of Justice from the Old
Bailey, including a blindfold and a garter with an
American dollar bill. A statement was read out by
MC Dynamite on Banksy's behalf: "It's the most
honest depiction of British justice currently on
display in the capital." Banksy apparently said, 'I
hope it stays there for good'. A posh plaque on it
read 'Trust No One'. The statue was taken away by
the council 2 days later.

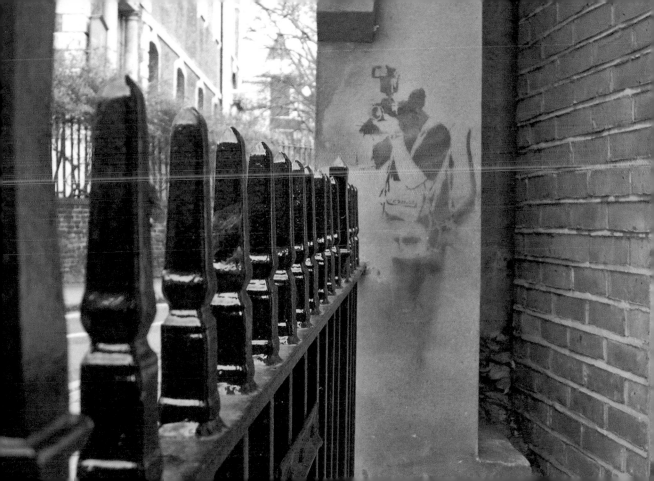

## THUGS FOR LIFE/OLD SKOOL

This existed in a small car park on Clerkenwell Rd (A5201), near Saffron Hill (postcode: EC1R 5DL. Map/GPS reference: TQ 31299 82030). Before the pensioner thugs with their B-Boy gear, zimmer frames and bling turned up in 2004, a small rat writing 'Because I'm Worthless' existed on this wall. It had various titles added above it over the years, including 'Thugs For Life' and 'Old Skool'. The massive, and probably painstaking, stencils for the piece are shown at the end of the edition of *Wall and Piece*.

In mid-January 2008 an awful-looking mish-mash of metal hoardings suddenly covered it up. It reminded me of the shanty towns in Addis Ababa where I used to live. On the 26th February it was opened up again. The wall was now mainly blank, but had a Banksy-style 'cut out and collect' surrounding where the graffiti used to be, and had 'collected' stencilled in the middle, in large letters. Now that is what I call a sense of humour! Within a day this tongue-in-cheek message was whitewashed though.

On 4th March 2008, the *Evening Standard* ran a story about the removal, with a typically subtle headline: "Banksy, taken off wall by German, now worth £300,000", as if the buyer's nationality was important!

The article reported, "Today, it emerged that... the owner of the garage has sold it — for £1,000.

The buyer spent about £30,000 having the image 'peeled' from the wall by a specialist firm... The mural's new owner has chosen, like the artist, to remain anonymous but he is thought to be a German man in his 30s who works in advertising." Not that anonymous then, eh? :-)

It continued, "Olly Pugh, manager of Clerkenwell Motorcycles in Clerkenwell Rd, insisted the building's owner was happy with the price he had agreed for the painting. He said: "No one knew too much about Banksy at the time and he thought, 'If some idiot is going to give me £1,000 for a mural that's great'. Part of the deal was that he will get a life-size reproduction of the mural." The picture was removed by Tom Organ of the Wall Paintings Workshop in Kent. It took Mr Organ, who normally helps restore medieval wall paintings, six weeks to complete. He said: "We stuck some film over the top of the mural with an adhesive and gradually cut and peeled away quarter-millimetre-thick sections of the paintwork. We put the pieces back together like a jigsaw on a new support and then removed the film with a solvent that wouldn't damage the paint. I think my client was looking for about six months before he found a conservation company that could do the job but the techniques have been around for years... It's ironic because I've spent most of my life trying to keep paintings on walls."

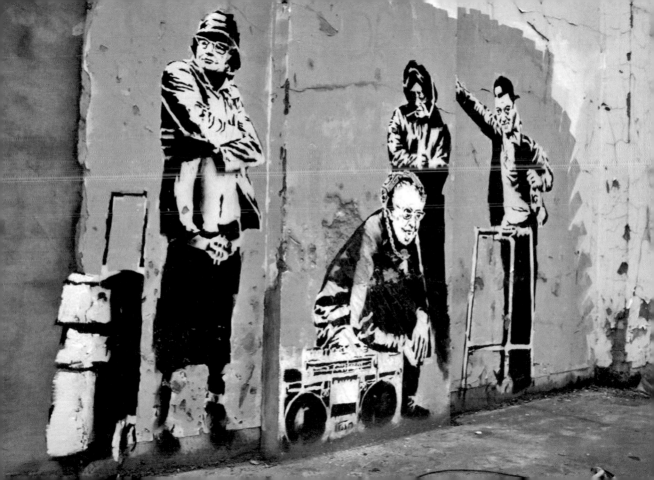

## GANGSTA RAT

This used to be on Roseberry Avenue (A401), very near the junction with Farringdon Rd (A201) (postcode: EC1R 4QD. Map/GPS reference: TQ 31193 82422).

It was on the metal delivery box of City News (4 Exmouth Market) from at least mid-2004, but in October 2006 it was reported that the whole box had been sold off by the shop. A nice shiny new one replaced it. By November it was already being sold on eBay.

It was later shown at a certain West London gallery in February–March 2008. And also later turned up in July 2009 at an awful 'exhibition' of ex-street works by Banksy in Covent Garden, London. It was badly entitled Please Love Me – Banksy and contained a large amount of what they called 'architectural' pieces (others would call them ripped off street pieces!). If this continues I think I might have to rename it 'prostituted rat' soon.

Please remember that this book is *not* provenance that a piece featured here is by Banksy and can probably be sold for the price of a small house. This book is just a bit of fun and is no guarantee that something is by Banksy. Street pieces are meant for the streets, and were not made as conversation pieces in posh people's reception rooms.

A rather strange metal cube used to existed nearby. For no obvious reason it just sat there in spring 2004, by a tree next to the main road. It had a small Banksy umbrella rat added to it (like the one at location S8) but soon disappeared.

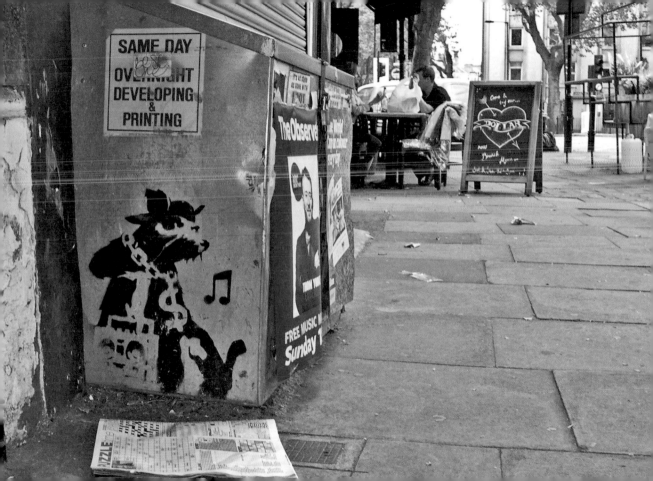

# F12

**CASH MACHINE & GIRL**
Postcode: WC1X 0DW
Map/GPS reference: TQ 31148 82454

## Location & Seemingly Endless History & Chatter

Roseberry Avenue (A401), very near the junction with Farringdon Rd (A201).

It's a cash machine with a mechanical arm grabbing a girl. What on earth does this mean?

Enough thinking time, peeps... A long time ago this site started as just a small Banksy umbrella rat on an old disused window. The first photo I've seen of it was from April 2004, although it may have been there a bit earlier. By May a big black rain cloud had been added above it (not sure if that was by Banksy or not, but it suited it well). By mid-2005 the window had been bricked up and the cash machine had been put up over it, with Banksy/D*face's 'di-faced tenners' (£10 notes with Princess Di on them instead of the Queen) spewing out of it. It was this 2005 incarnation that is shown in the *Wall and Piece* book. The tenners didn't last long, and a bit later in 2005 the arm and girl were added (see main photo).

A version of just the cash machine (in Vienna) is shown in 'Cut It Out'.

Wasn't that history lesson interesting? I swear I could have been a teacher; I would have loved to try the leather elbow patch and tweed look.

It was boarded up in February 2008, just after it had been 'vandalised'. Maybe that episode prodded the 'owner' to then cover it up before more damage happened.

In spring 2008 this piece was on sale on eBay. It was first offered with a starting bid of $300,000 but received no bids and was then re-listed with a £120,000 start.

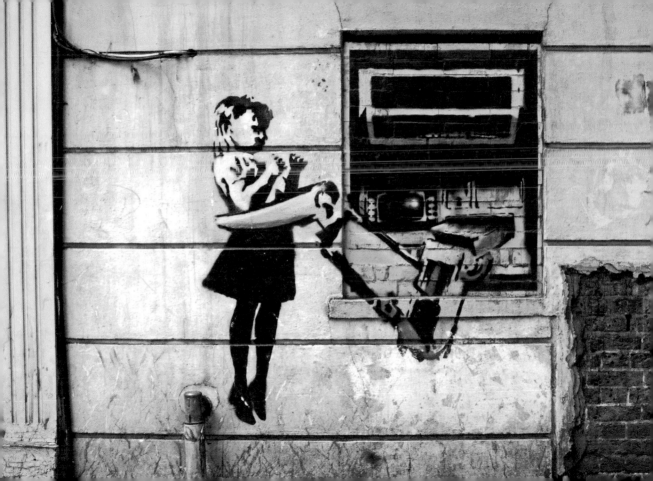

The description of the piece said, "Due to planned building work we are pleased to offer this iconic 'cash machine girl' a well-documented original Banksy up for closed auction. The centre-piece is on a bricked-up window and will be removed as one piece, this and the rest of the work will involve conservation specialists in a controlled removal. The detached piece will be mounted on a new lightweight surface replicating the original wall and can therefore be presented free-standing or hanging when completed. The company that we strongly recommend to undertake this work have done this a number of times before with Banksy works of art...The cost of this work is put at around £29,000.00... The painting is in fair condition at the present time...there are localised areas of flaking paint, but in general the paint layers are stable. There are areas of recently applied white emulsion over parts of the painting, but tests indicate that this can be carefully dissolved and removed from the stencil painted surface without damage to Banksy's work. At present the painting is covered and boxed-in."

Considering the piece is still on the wall and still has the large strips of paint on it, I assume that nothing happened in response to this ambitiously sad sales pitch.

**Status**

In mid-October 2009 it was suddenly revealed again (not long after the shop next door changed its name to 'Banksy Bagel Bar' – LOL), although it was now under some complicated plastic and wood protection. In June 2010 the 'shop' on Banksy's website showed a photo of the bagel bar and commented that "Banksy does not produce greeting cards or print photo-canvases or paint commissions or sell freshly baked bagels"! The two large strips of paint are still there (June 2011) so presumably the owner of the wall hasn't tried to restore it (see the recent photo opposite; which is probably the only time I'll be in the same photo as Cheryl Cole, a Banksy, and a 'Banksy Bagel Bar'!). Nice to see it again, though, after all this time away.

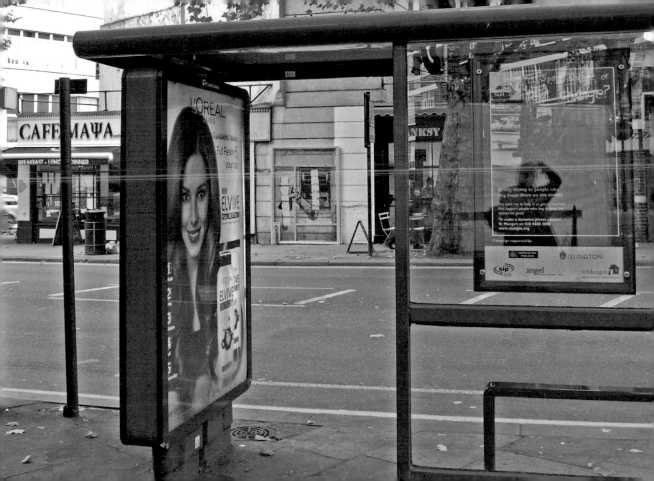

**PAPA'RAT'ZI**

This was on the entrance wall of the Movie World shop, on Exmouth Market, from at least early 2004 (postcode: EC1R 4QL. Map/GPS reference: TQ 31296 82489).

It was another good example of the mutant photographer-cum-rat. At one point the wall seems to have been repainted, and they carefully painted around the Banksy.

But it slowly got worse and worse, and by mid-2009 just bits of the face were left. When I walked past in October 2009 the wall was totally white and the Banksy had gone. The shop had also changed to McCaul Goldsmiths.

By the by, the building has an English Heritage blue plaque on it. It tells us that the famous clown Joseph Grimaldi lived there from 1818 to 1828. Every year a memorial service is held for Grimaldi at the Holy Trinity Church in Dalston. Clowns from all over the world come in full clown clobber. Now that's what I call a service worth going to! Some great photos are available at www.ukstudentlife.com/Ideas/Album/ClownService.htm

A Clowns Museum/Exhibition also exists at Wookey Hole in Somerset, so if you are visiting Banksy's 'This Is Not a Photo Opportunity' stencil in Cheddar Gorge (see *BLT Vol 2*), you can follow up the clown connection there. I bet my mother will be so proud of me: from budding writer to washed-up clown expert all in the space of a few cider-soaked years. .

**PLACARD RAT – 'ALWAYS FAIL(E)'**
Postcode: EC1R 3AS
Map/GPS reference: TQ 31011 82486

**Location & Various Tittle-Tattle (oh, and Team Robbo again...)**
By a bus stop on the Farringdon Rd (A201), near the junction with
Calthorpe St.

This shows another example of Banksy's placard rat. It's been
there since at least mid-2005 and used to say 'Always Fail' but was
slightly amended in mid-2006 to read 'Always Faile', which may or
may not be a cheeky pun from the Faile crew!

'Always Fail' is also a nickname for the Royal Mail, whose massive
Mount Pleasant sorting office can be seen in the background of the
photo. I used to do some casual work there, and it really is as grim
as you would expect and the managers there really do always fail.
(The real workers are nice and having things like yam and plantain
in the canteen was a nice touch for the distinctly multi-cultural
workforce.)

In late February 2010 the placard was amended to read, in chunky
black marker pen, 'Team Robbo!', presumably as part of the fallout
from the now infamous 'Robbo' incident (in December 2009 Banksy
amended/went over a very old piece by veteran writer Robbo on the
Regent's Canal in Camden, and all hell broke loose afterwards).

**Status**
Faded, but still there and looking pretty good, despite the message
amendment (June 2011).

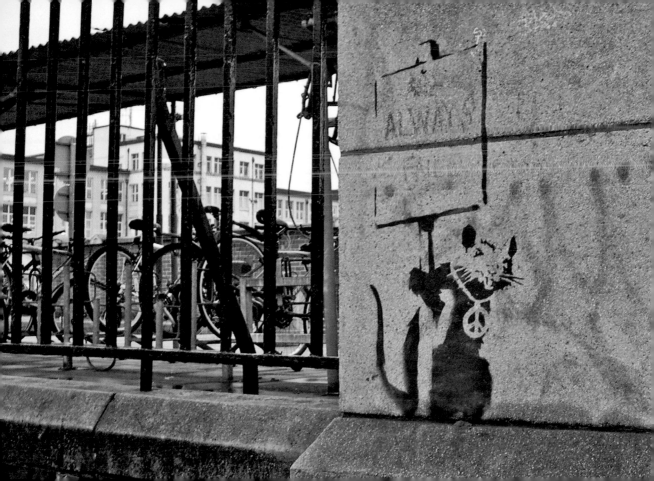

# WATERLOO, SOUTH BANK, & VICTORIA EMBANKMENT

## A.K.A. THE RIVERSIDE RAT TOUR

This tour went around the Lower Marsh/Waterloo area, then all along the South Bank from the Mortar Rats (opposite the houses of Parliament) to London Bridge, before crossing over the river to visit the ones on the North side of the river, finishing at Embankment tube station. The route went close to lots of tourist attractions and in some ways was the nicest of them all.

The featured graffiti on this tour has pretty much been obliterated over the last three years. There are a few still worth visiting, but don't drag your other half along the whole route, as they might end up very unimpressed at your geekdom!

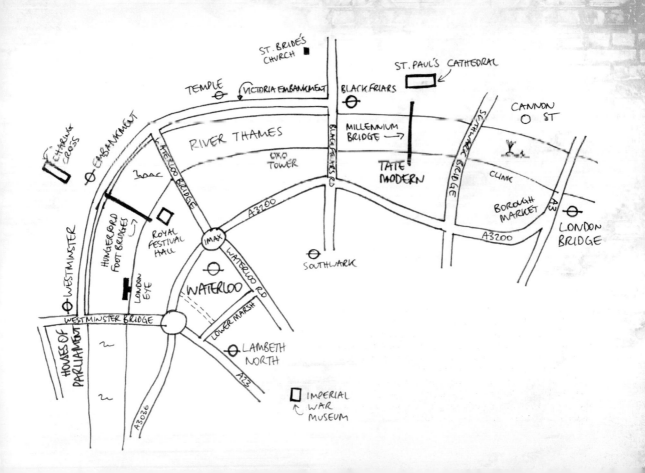

## WRITING RAT

This rat was on the corner of Lower Marsh and Baylis Rd (postcode: SE1 7AB. Map/GPS reference: TQ 31209 79751)

It seems like Banksy blitzed the Lower Marsh area at some point, as this one and the next three locations were all along this historic street. This is a rat piece I've not seen elsewhere, with a marker pen in its hand. It was on a metal telecoms box (always a favourite Banksy target!) but had already been buffed even before the first edition of *BLT* struggled out from the printers in late 2006.

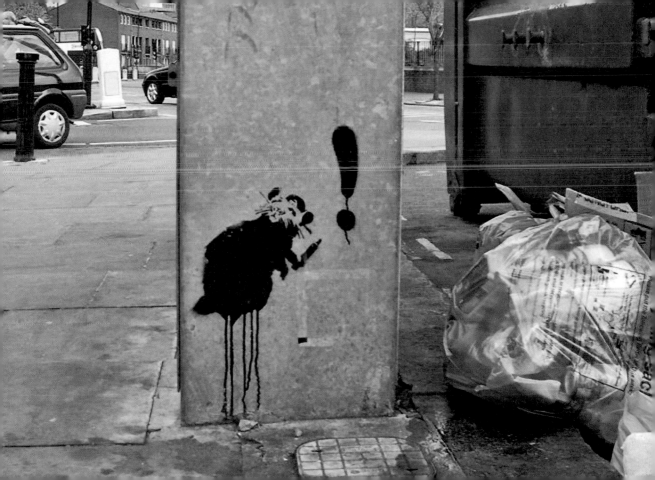

**GHETTO BLASTER RAT**
Previously on the metal box outside 'Supreme General Stores' on
Lower Marsh (postcode: SE1 7AB. Map/GPS reference: TQ 31161
79762)

On one of Banksy's favourite mediums, the metal boxes outside
newsagent shops. This one was often partly obscured by posters.

The entire metal box later vanished and was replaced by a nice
new one. A man in the shop told me it had been stolen (in about early
February 2007, I believe).

In April 2008 my wonderful mate Stef, who did the original graphic
design for this book, plus various flyers and publicity materials,
and who smoked copious fags, in typical arty mode, was wandering
in Hong Kong (as you do...), during what was mainly a trip to the
Philippines (as you have...) and came across a show of Banksy art, at
the Schoeni Art Gallery. It included this rat, on the metal newsagent
delivery box. Considering that the owner of the shop told me it had
been stolen, I don't know what to believe now!

Part of the exhibition was originally at the Hong Kong Arts Centre
the week before, and was entitled 'Love Art' (although publicity
material liberally used the embarrassingly bad phrase 'Banksy robs
Hong Kong' on it, in big letters). It rather controversially seemed to
suggest that Banksy was 'exhibiting' there, whereas I would think it's
safe to assume he had absolutely rock all to do with it.

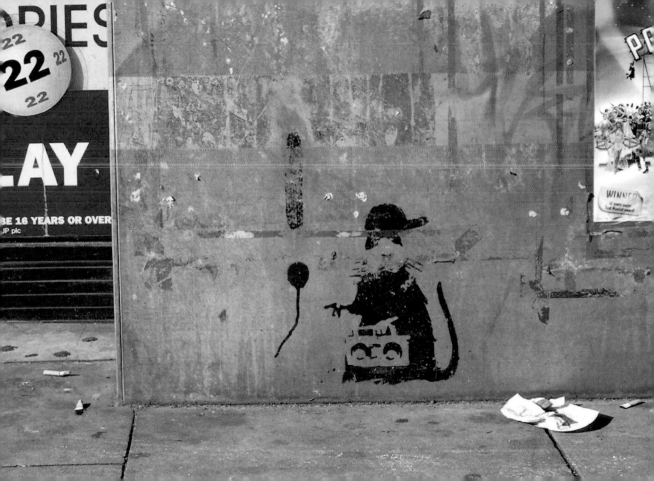

**DESIGNATED PICNIC AREA**

On the side of a skanky alley about halfway along Lower Marsh (next to what used to be 'Crockatt & Powell Booksellers' – Postcode: SE1 7AD. Map/GPS reference: TQ 31070 79688)

    This had been there since at least mid-2004 and the arrow invariably pointed to a pile of bin bags or rotting veg! Lower Marsh is still an active and historic market area.

    Still very slightly visible (see inset photo) but it was pretty much buffed by the local Council in late 2006 even though the bookshop owners didn't want it removed and had told them that! In other words, they went against the 'laws' of graffiti removal – isn't it rather ironic that there are 'laws' on removing graf?

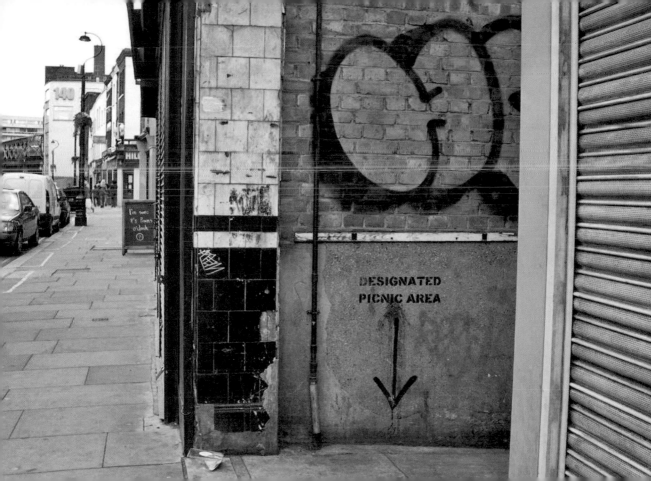

## HELP ME RAT

On the metal box outside a newsagent on Lower Marsh (opposite Ryman's – Postcode: SE1 7AE. Map/GPS reference: TQ 31017 79637)

This was a rat piece I've not seen elsewhere; a rat scrawling 'help me'. It had been happily sitting on a newsagent's metal box since at least mid-2005, but in early 2007 the 'help me' phrase was scrawled over (see inset photo). By mid-March the whole box had gone and the shop always seemed to be closed. Later I was emailed out of the blue by the new 'owner' who said that he bought the box from the newsagent before it closed down.

In April 2009 it appeared in an art auction, by an auction house that should not only know better but also doesn't deserve the publicity I might accidentally give them. I want to give information about these pieces, but I don't want in any way to help these people to try to sell pieces that were created for the streets, not for auction houses, trendy bars or living rooms. If you are bored enough to want to know what I think about this issue, see the 'Buy Bye Bye, Sale Sell Sell' rant at the start of the book.

Four of the five street pieces in the auction failed to sell, and the fifth (this one) was withdrawn before the auction.

This unfortunately was later being touted by Bankrobber Gallery (see F8 above for a similar story). I hate giving them publicity, but I do have to document what has happened to this piece. I was surprised at the photo on their website because last time I photographed it on the street the 'help me' writing had been dogged.

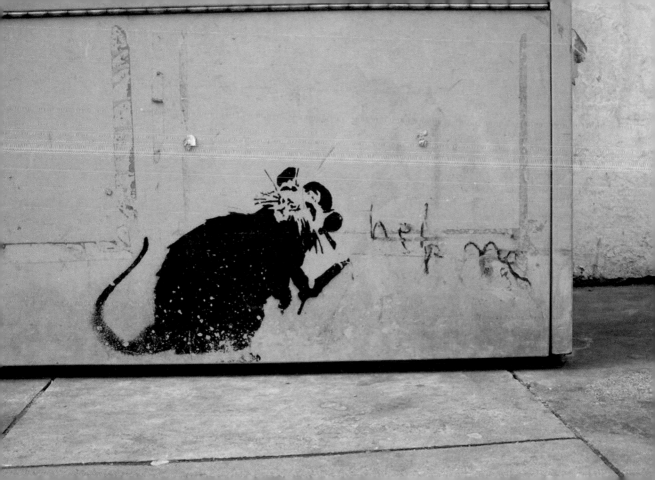

**MONKEY DETONATOR**

This was in the tunnel underneath Waterloo train station (Leake St – Postcode: SE1 7AE. Map/GPS reference: TQ 30997 79717).

When I took a group on a tour of graffiti in Shoreditch, one comment was that 'I've never been in so many skanky alleys in my life'. This Waterloo underpass was far more wee-stained skanky, as a monkey detonates a bunch of bananas...

A photo of it is shown in the *Wall and Piece* book, which dates it to 2003, and it has also been shown on his website.

It was painted over in October 2006 (see inset photo) and once the press heard about it many months later (and had printed the seemingly obligatory half true story), there were a few transport bosses left with egg on their faces at painting over 'a Banksy'.

This tunnel later became famous as it hosted The Cans Festival, a special free event that took place on the May Bank Holiday weekend in 2008 (see *BLT Vol 2* for more details and loads of photos). Banksy (and many others) did loads of stencil-based work in the tunnel, and the public were invited to queue up and look at it. About 28,500 people did so, including me. The tunnel later was refreshed by more traditional graffiti writers, and in February 2010 it was also the site for the cinema that premiered his film *Exit Through the Gift Shop*.

An early version of this image was used years previously in Bristol. It was smaller, had a shorter cord, and the explosive was still traditional sticks of dynamite. A canvas of that version was sold at the Severnshed exhibition (Bristol) in early 2000.

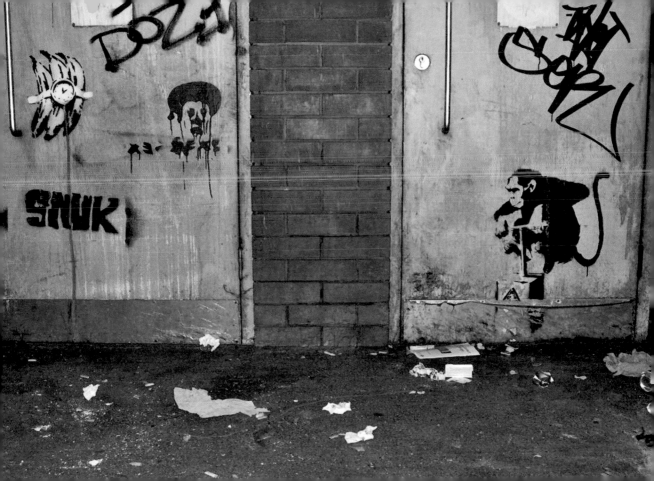

**SNORTING COPPER**

Banksy's infamous Snorting Copper used to be just outside of the tunnel underneath Waterloo station (Leake St – Postcode: SE1 7NN. Map/GPS reference: TQ 30890 79791)

It was partly shown in *Wall and Piece*, which dates it to 2005. The book mixes and matches photos of this one with the white line from the one that existed in Shoreditch (see location S19).

By the time of the Cans Festival in May 2008 (see location R5 for basic details) it still just about remained. But it got surrounded by other graf, and was constantly photographed by people who seemed to think it had been done for the festival!

The whole wall was surprisingly blackwashed in September 2008, thus totally wiping out the copper. I say surprisingly because it was that wall that stated that the Cans site was maintained by 'blank expression' – www.blankexpression.org – the company that helped get permission for the festival, and which administers 'legal' areas/walls that people wish to donate.

Note the lovely Space Invader above it (see inset photo). It has since gone though.

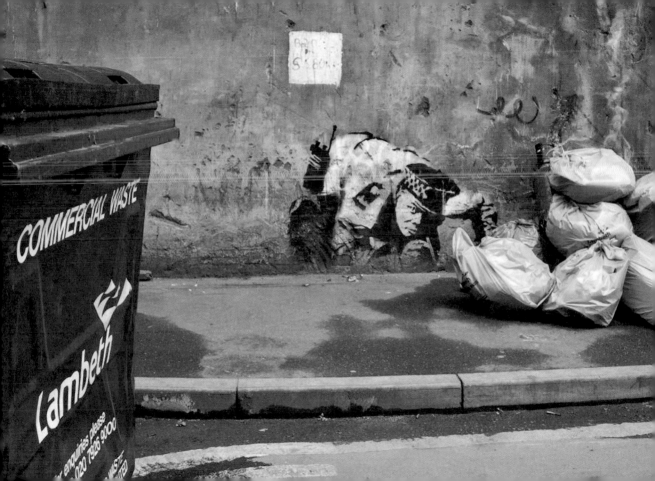

## MORTAR RATS

Two separate (but similar) examples of these rats existed on the riverside granite blocks of the pedestrianised walk of the South Bank from about 2003. One was close to Westminster Bridge (postcode: SE1 7EH. Map/GPS reference: TQ 30575 79516). The other was several hundred metres further up, towards Lambeth Bridge.

The Houses of Parliament and 'Big Ben' can just be spotted, looming in the background, their assumed 'target' (see inset photo for possible trajectory).

The one on my main photo is shown in Banksy's little *Existencilism* book, next to a comment that "Rats are called rats because they'll do anything to survive." It was also on his website.

Banksy's tag was just visible in the corner of each. One had some diving figures added to it (see inset photo); I presume those were not by Banksy as they seem to spoil the composition.

Despite being untouched for many years, both were buffed in mid-2007, although the small tag can still be spotted on one.

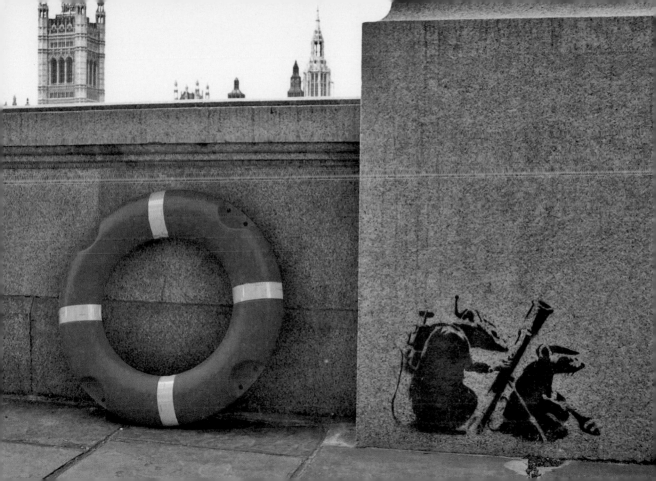

**THIS IS NOT A PHOTO OPPORTUNITY**

This was on the riverside granite blocks of the pedestrianised walk of the South Bank, close to the London Eye (by the largest Dali statue) from at least early 2003 (postcode: SE1 7JA. Map/GPS reference: TQ 30594 79812).

This was possibly Banksy's most photographed stencil, as many people deliberately or accidentally got their photos taken here (it overlooked the houses of Parliament). Photos of tourists looking dumb are included in the *Wall and Piece* and *Existencilism* books.

It was surprisingly buffed in mid-February 2007. I say surprisingly because it had been there about four years, so it seemed a bit random that it was buffed then, rather than before.

This stencil is his most travelled and has been used in Glasgow, Havana, Paris (used twice in the same area – placed so they could be photographed with the Eiffel Tower in the background), and Sydney (ditto, but with the Opera House in the distance). It was also used twice again along the South Bank (see locations R11 and R12), as well as in the Swiss Embassy car park in London, and on a rock face in Cheddar Gorge, Somerset (see *BLT Vol 2* for both of those).

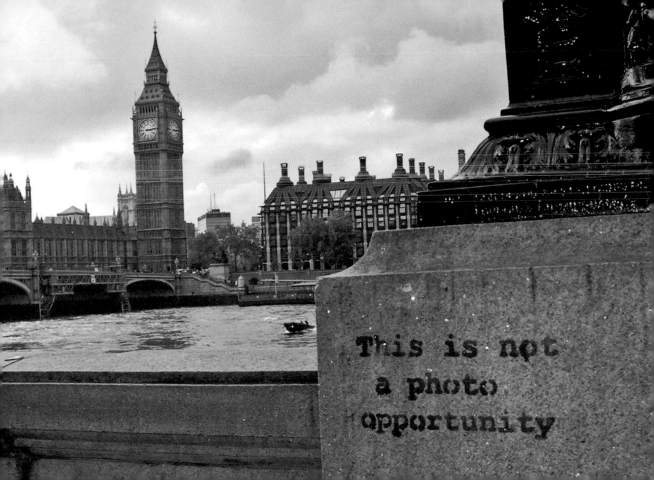

# BLT TIP

This area (R7 to R9) is a good area to spot the white line on the South Bank walkway.

This was a white line that stretched for a long way. It seems to start around the London Eye area, and runs along the South Bank, over Lambeth Rd and around the houses to a bridge in Whitgift St. I thought a snorting copper was supposed to be at that end but I've never seen a photo of it and nothing could be seen when I first 'walked the line' in 2006.

It was partly shown in *Wall and Piece*, which dates it to 2005. The book mixes and matches photos of this white line and the one that existed in Shoreditch (see location S19). And it also shows the Snorting Copper at Waterloo (location R6) as if the white line (or another white line?) was supposed to go there...

## SAWING RAT

This was on the riverside granite blocks of the pedestrianised walk of the South Bank from at least 2003, just before the Hungerford Footbridges (postcode: SE1 7NN. Map/GPS reference: TQ 30890 79791).

It was a rare sawing rat, complete with cigarette and beret. The circle on the pavement that accompanied these sawing rats had gone before I took this photograph though.

It then faded away over the years and was fully buffed in mid-2007.

**BLT TIP:** There were two Girl with Balloon stencils along the South Bank. Both have gone, but are still slightly visible. One was on the East side of Waterloo Bridge (by the National Theatre). The other was on the East side of Blackfriars Bridge. There were also a few 'Buried Treasure' stencils along the riverside walk but they have also virtually gone.

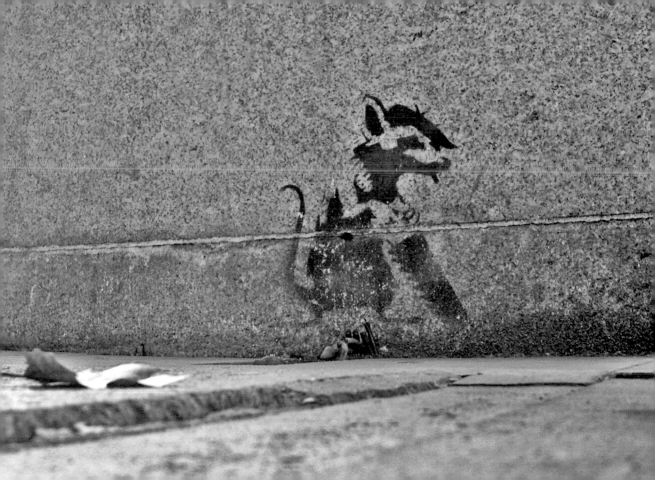

**GHETTO BLASTER RAT**
Postcode: SE1 8XZ
Map/GPS reference: TQ 30764 80331

### Location
On the riverside granite blocks of the pedestrianised walk of the South Bank. On the entrance to Festival Pier (opposite the Queen Elizabeth Hall).

It has been there since at least spring 2004.

### Status
Still just there but it has previously been scrawled over with some bubble graffiti, which was then removed, meaning the Banksy is very, very faded and not really worth a visit.

**BLT TIP:** 'BORING' was infamously sprayed by Banksy, using a modified fire extinguisher, in massive red letters on the Waterloo Bridge side of the National Theatre.

# R11

**THIS IS NOT A PHOTO OPPORTUNITY**
This was on a rusting old rubbish bin, on the pedestrianised walk of
the South Bank, right outside the Tate Modern (postcode: SE1 9TG.
Map/GPS reference: TQ 31973 80541).

  It had been there since at least 2003, but the bin slowly rusted
away until it was freshly painted in mid-2007.

  Note the Banksy 'homage' also in the photo, dating from 2004.
It's of a tiny weeing soldier (a classic older Banksy piece), tagged as
'spank me', using the typeface (Stop) that Banksy uses for his tag.

## THIS IS NOT A PHOTO OPPORTUNITY

This was rather famously on a lovely old building on Park St, behind Borough Market (postcode: SE1 9TG. Map/GPS reference: TQ 31973 80541).

It was there since at least 2003 and I was always surprised how long it lasted, considering how historic the building is. The building was used as the hideaway in the film *Lock, Stock and Two Smoking Barrels*, and I've also spotted several magazine photo shoots that have used this location (and the stencil). Maybe irony is lost on them?

A black stencilled 'flying box' was added right above the Banksy in mid-2007 (see photo – by the by, is it just me or are those man's shoes too big for his body? Discuss amongst yourselves for a minute whilst I get back on track with the graffiti research). It was by a South African artist called 'straat-toe' which translates (from Afrikaans) as 'to the streets'. Both were heavily sandblasted off in January 2008.

**BLT TIP:** As you walk past the 'London Bridge Tandoori Restaurant' on the south side of London Bridge, you might recognise the advertising hoarding where Banksy scrawled 'The Joy of Not Being Sold Anything'. As previously show on a video on Banksy's website, and in the *Pictures of Walls* book. Postcode: SE1 9QG/Map/GPS reference: TQ 32701 80267

**PLACARD RAT – 'YOU LOSE'**
Postcode: EC4R 3UE
Map/GPS reference: TQ 32586 80661

### Location & The Bit Where I Get All Serious (for once...)

At the riverside end of All Hallow's Lane (underneath Cannon Street station). A glimpse of it was briefly featured in his film *Exit Through the Gift Shop*.

This really sticks in my mind because when I first visited it, I found a guy next to it, living in a cardboard box, with little except a radio and a blanket. It felt really meaningless to take the photos, and also it could be demeaning to him. I talked with him for a long time, and asked 'permission' to take a photo of the wall (not getting him in the photo).

The irony of the placard message dug home. This is just one reason I support The Big Issue, try to talk to people I meet rather than just pass them by, and try to help them a little. I don't always succeed in doing this, so I need hefty reminders sometimes.

### Status

It's been there since at least mid-2005, and although it has faded a lot in the last year (2010–2011), it is still visible. It survived the tunnel being redeveloped in 2007–2008, but now (June 2011) it's being worked on again.

**BLT TIP:** It is difficult to explain how to get to R14 from here. A map and the use of the subways at Blackfriars station will help.

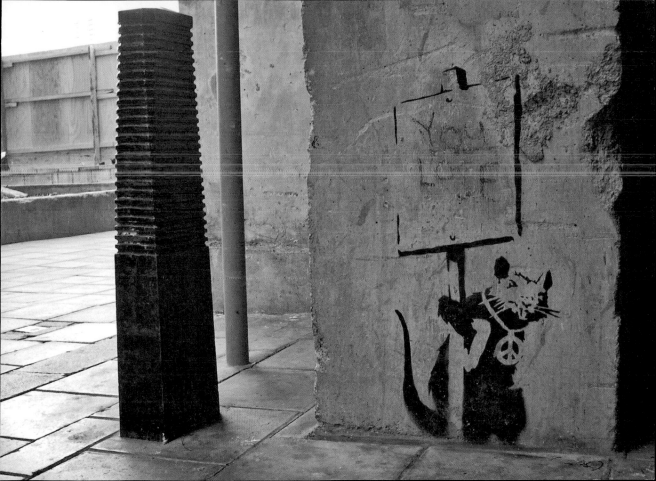

**POISON RAT**
Postcode: EC4Y 8AU
Map/GPS reference: TQ 31573 81134

### Location & Stuff about Churches & Green Waste (that isn't Friday night sick)

Just off Bride Lane. This has been on the steps of a little passageway to St. Bride's Church since at least late 2005.

Although this has never been the greatest Poison Rat in London, I always think it is the one with the best setting, as it not only has St. Bride's Church (the famously historic 'Fleet Street' church) in the background but also cleverly uses the steps as if the rat is pouring the toxic waste down them.

### Status

Faded but still there (November 2010).

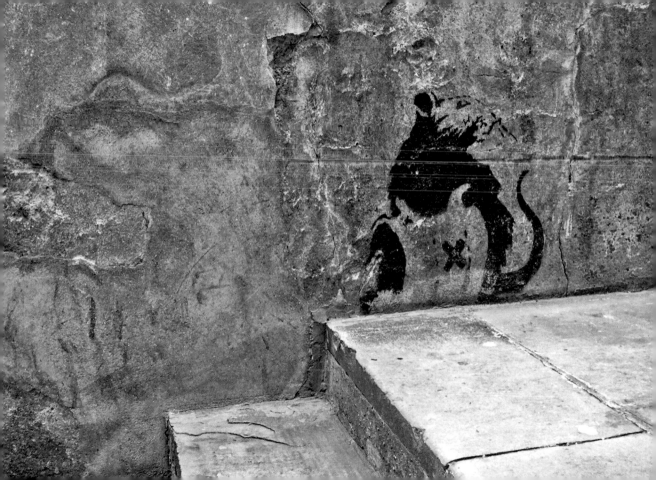

# R15

**PHOTOGRAPHER RAT**

Previously on a metal utilities box on the Victoria Embankment (A3211), just after Blackfriars (near the boat HMS President – Postcode: EC4Y 0HJ. Map/GPS reference: TQ 31320 80802).

Again, this Banksy stencil seemed to get given respect by others. Each time I saw it, since early 2005, it had a different variety of stickers surrounding it, but they were always around it rather than directly on it.

In late 2008 it seems as though the box was removed and replaced by a different one. Slightly strange eh? How did they manage that? In January 2009, the box was offered for sale on Gumtree, the popular Aussie/Kiwi/Saffa/Hippie layabout website (and had apparently been on eBay before, although I didn't see that). The cheeky monkey even referenced my book as some sort of provenance (see the 'Buy Bye Bye, Sale Sell Sell' part at the start of this book for a rant about people who do that). Being in my book doesn't mean it is by Banksy! Only he can positively confirm or deny that, and he won't. So there is no real provenance for street pieces, and quite right too.

In April 2009 it then appeared in an art auction, by an auction house that should not only know better, but also doesn't deserve the publicity I might accidentally give them. I want to give information about these pieces, but I don't want in any way to help these people to try to sell pieces that were created for the streets (not for auction houses, trendy bars or living rooms). It had an estimate of £12,000–18,000 attached to it, plus the dreaded 'Vermin Certificate of Authenticity'. They said it had been 'salvaged' from a 'decommissioned telephone exchange box'. At this point I felt like screaming. People used to actually work for a living and produce things. Now they just rent out property and try to sell street art.

Four of the five street pieces in the auction failed to sell (including this one), and the fifth was withdrawn before the auction.

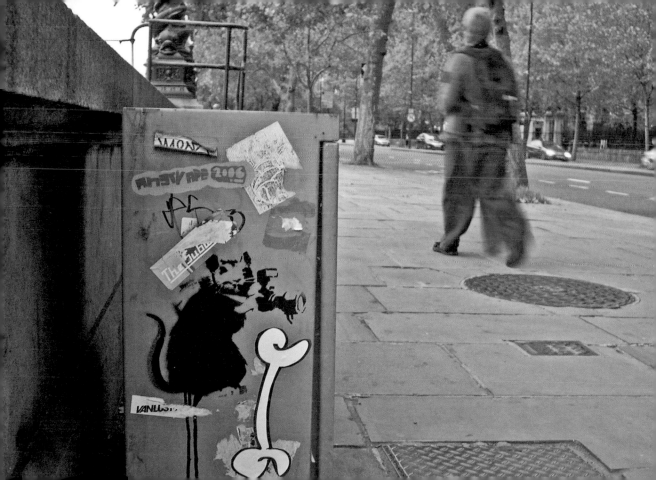

**PLACARD RAT – QUESTION MARK**
Postcode: WC2R 2PP
Map/GPS reference: TQ 31043 80786

**Location & Hopeless Attempts at Small Talk (I am a man after all...)**
On the granite section of the riverside wall, near a memorial on the
Victoria Embankment (A3211). Close to the boat HQS Wellington.
Opposite Temple tube station. Is that enough location info for you? :-)

An excellent placard rat, with a big question mark on the placard.
It's definitely been there since February 2005 but probably actually
dates from around 2003.

A small photo rat used to exist on the Temple Place side of Temple
tube station (opposite Arundel St), but it went quite a while ago. It
does show though that this area has had a lot of Banksy stuff dotted
around it.

**Status**
Still visible (May 2011) but very faded (a bad buff job I assume).

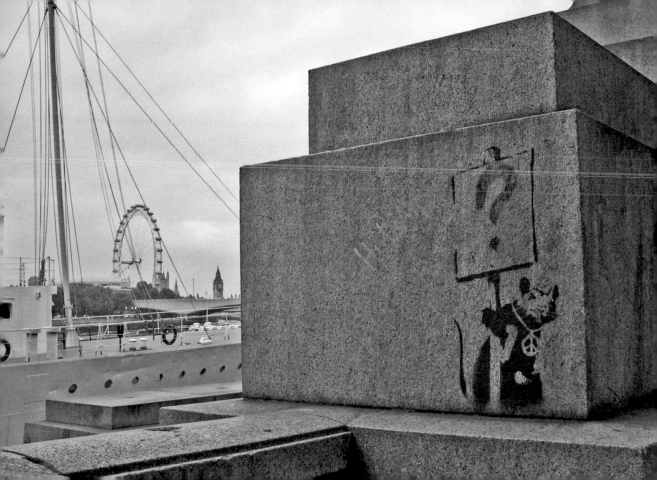

**PHOTOGRAPHER RAT**
This was above a green utilities box under Waterloo Bridge (the corner with Savoy St), until it was buffed in mid-2007 (postcode: EC4Y 0HJ. Map/GPS reference: TQ 31320 80802).

That's me, that is. A photographer rat.

This was a very clean rat until rude, and frankly rather confused, graffiti was added close to it, something about polos, Banksy and an unnatural act...

Note the 'Cept' tag on the utilities box, a rare sight this far south.

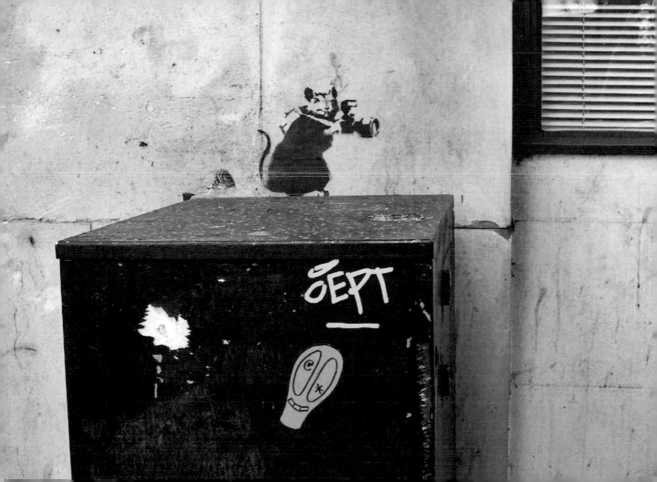

**PLACARD RAT – 'GO BACK TO BED'**

Previously on the massive concrete struts of the Hungerford footbridge (east side), opposite Embankment tube station, on the Victoria Embankment (postcode: WC2N 6NS. Map/GPS reference: TQ 30438 80323).

Another 'Go Back To Bed' rat, spreading the gospel since at least mid-2004. It was perfectly placed to catch commuters and early-morning joggers, both of whom really should know better.

It was buffed in mid-2006, even before this book could actually see the light of day.

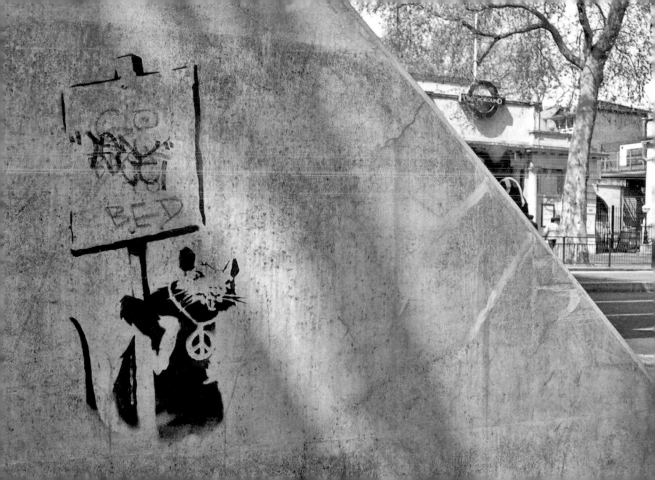

# THANKS & ACKNOWLEDGEMENTS

Obviously the real credit must go to all the writers who do their work on the street, especially Banksy of course. Please support them. Links to their websites etc. are below. The first and main thanks has to be for the wonderful Stef who started this whole crazy thing off by asking me, in one of those Friday afternoon moments, if I had ever thought of making my free tours, info and photos into anything more, such as a book. I had – great minds think alike, eh? – but the book mapped out in my head was on Eine, not Banksy. That's how *BLT* started, on the back of a napkin, even though I'd never really done anything like this before. After a lot of hard work, *BLT* arrived and was updated regularly over the next few years. He pushed me all the way through the process, did all of the painstaking graphic design for the first three UK editions (plus the print preparation, flyers and anything I needed!) and put up with my perfectionism. I'm genuinely not sure if this would ever have got done without him and I owe him so much love!

The second thanks has to be for Sam, who handled all the print brokerage, helped me on the streets (no, he isn't actually my fixer... although it may feel like it some times), generally encouraged me, and was always around for a chat and a wander.

General respect to Steve at Art of the State and Tristan Manco, godfathers of graffiti info, knowledge and photographs.

And as mentioned at the start of the book, thanks to all the people who responded to my leading questions and annoyance of where to find some of this graffiti. Although this book is in no way sanctioned by Pictures On Walls or The Big Issue, I greatly respect them both and give thanks for their existence. Particular thanks to lovely Steph who used to manage POW.

## CREDITS

All photographs (bar three – see below) and text are by Martin Bull. Hand-printed, limited editions of his black-and-white photos of graffiti are sometimes available via eBay and/or www.shellshockphotos.co.uk, depending on whether he has dark room facilities at the time and can pull his finger out... ↬ Many thanks to Dave and Juliette for their photograph of the Shoreditch tour in September 2006 (shown just before location S18) ↬ Many thanks to Sam for his photograph of the tour of Waterloo/South Bank in August 2006 (shown at the introduction to that section) ↬ Many thanks to Karen Richardson for her photograph of the Bomb Hugger at Fabric (location F6) ↬ Many, many thanks again to Stef at Hoodacious – www.hoodacious.co.uk – for the original graphic design of the UK version of this book and all the updates up to the third edition, plus the print preparation and generally being there to help.

## WEB LINKS

**BANKSY** www.banksy.co.uk
**PICTURES ON WALLS (POW)** www.picturesonwalls.com
**FAILE** www.faile.net
**AROFISH** www.arofish.org.uk
**SPACE INVADER** www.space-invaders.com
**OBEY (SHEPARD FAIREY)** www.obeygiant.com
**BLEK LE RAT** http://bleklerat.free.tr/ & http://blekmyvibe.free.fr
**CEPT** www.spradio.com
**EINE** www.einesigns.co.uk
**BEFORE CHROME/BURNING CANDY** theburningcandy.blogspot.com
**D*FACE** www.dface.co.uk

**MANTIS** www.themantisproject.co.uk
**ART OF THE STATE** www.artofthestate.co.uk
**THE MIGHTY GAS** www.bristolrovers.co.uk
**GRAFFOTO BLOG** www.graffoto.co.uk
**TU INK** www.tuink.co.uk
**POGO CAFÉ, HACKNEY** www.pogocafe.co.uk
**THE BIG ISSUE** www.bigissue.co.uk
**HOODACIOUS** www.hoodacious.co.uk
**THE BANKSY GROUP ON FLICKR** www.flickr.com/groups/banksy
**BANKSY FORUM** www.thebanksyforum.com
**MY OWN WEBSITE** www.shellshockpublishing.co.uk

# BANKSY LOCATION & TOURS VOL 2

## A COLLECTION OF GRAFFITI LOCATIONS AND PHOTOGRAPHS FROM AROUND THE UK

### ISBN: 978-1-60406-330-7
### 176 pages $20.00

This unique and unashamedly DIY book follows the runaway success of *Banksy Locations and Tours Vol 1* by rounding up the best of Banksy's UK graffiti from the last five years. It includes over 50 different locations and 125 color photographs of Banksy's street art; information, random facts, and idle chit-chat on each location, along with snippets of graffiti by several other artists.

Visit the locations in-person, or get your slippers on and settle back for an open-top bus ride though some of Banksy's best public work.

**"Are you a big fan of Banksy and got no plans this summer? Then this is the perfect book for you. A no-nonsense travel guide to all his London locations."**
—Waterstone's on *Volume 1*

**"Martin Bull charts the mysterious appearances—and sadly, sloppy destruction—of Banksy graffiti all over London, complete with maps and notes on the present condition of his works. Bull's unpretentious style and dedication to graffiti art comes across in everything he writes."**
—London Sketchbook on *Volume 1*

## ABOUT PM PRESS

PM Press was founded at the end of 2007 by a small collection of folks with decades of publishing, media, and organizing experience. PM Press co-conspirators have published and distributed hundreds of books, pamphlets, CDs, and DVDs. Members of PM have founded enduring book fairs, spearheaded victorious tenant organizing campaigns, and worked closely with bookstores, academic conferences, and even rock bands to deliver political and challenging ideas to all walks of life. We're old enough to know what we're doing and young enough to know what's at stake.

We seek to create radical and stimulating fiction and non-fiction books, pamphlets, t-shirts, visual and audio materials to entertain, educate and inspire you. We aim to distribute these through every available channel with every available technology — whether that means you are seeing anarchist classics at our bookfair stalls; reading our latest vegan cookbook at the café; downloading geeky fiction e-books; or digging new music and timely videos from our website.

PM Press is always on the lookout for talented and skilled volunteers, artists, activists and writers to work with. If you have a great idea for a project or can contribute in some way, please get in touch.

**PM Press**
**PO Box 23912**
**Oakland, CA 94623**

**www.pmpress.org**